IMAGES
of America

LOGGING IN WISCONSIN

ON THE COVER: A crew eats together in the woods. The cook and cookee would take lunch to the men in a wagon. If the crew did not have to traipse back and forth to the cook shanty, they had more time to work in the woods during daylight hours. (Chippewa Valley Museum.)

IMAGES
of America

LOGGING IN WISCONSIN

Diana L. Peterson
and Carrie M. Ronnander

ARCADIA
PUBLISHING

Copyright © 2017 by Diana L. Peterson and Carrie M. Ronnander
ISBN 978-1-4671-2532-1

Published by Arcadia Publishing
Charleston, South Carolina

Printed in the United States of America

Library of Congress Control Number: 2016953351

For all general information, please contact Arcadia Publishing:
Telephone 843-853-2070
Fax 843-853-0044
E-mail sales@arcadiapublishing.com
For customer service and orders:
Toll-Free 1-888-313-2665

Visit us on the Internet at www.arcadiapublishing.com

*"Give me six hours to chop down a tree and I will spend the
first four sharpening the axe." —Abraham Lincoln*

*We dedicate this book to those historians who spent so much time
sharpening the axe. We are especially grateful to Mert Cowley, Dale
Peterson, Chad Ronnander, and Malcom Rosholt for their detailed
research and illuminating writing about logging history in Wisconsin.*

CONTENTS

ACKNOWLEDGMENTS

All photographs not otherwise marked are from the Glenn Curtis Smoot Library and Archive at the Chippewa Valley Museum. Former Chippewa Valley Museum librarian Eldbjorg Tobin spent her career making the museum's archival and photograph collections more accessible to the public. With quiet perseverance, she catalogued thousands of photographs, including the ones in this book, and helped researchers across the state and nation find images and answers to pressing historical questions. We owe a great debt to Eldbjorg. Without her unsung work, this book would not have been possible.

The Langlade County Historical Society has an amazing collection of photographs, many taken by Arthur Kinsgbury. Joe Hermolin was especially generous with this collection and his time. Andy Barnett at McMillan Library in Wisconsin Rapids, staff at the University of Wisconsin–La Crosse Murphy Library Special Collections and the Area Research Center, Karen Furo-Bonnstetter from the Woodville Public Library, and US Forest Service staff at the Chequamegon-Nicolet National Forest responded quickly to requests to use photographs from their collections. They seemed to understand pressing deadlines. Dunn County Historical Society and Chippewa County Historical Society also provided assistance and access to their photograph collections. Fortunately for us, Gene Koci—a retired school administrator, Chippewa Valley Museum volunteer, and eternal student of the logging era—developed a presentation on logging just before the first draft of this book was due. We borrowed generously from his research.

For 30 years, the Chippewa Valley Museum and Paul Bunyan Logging Camp Museum have existed side by side, sharing a boundary line in Carson Park, Eau Claire. We are two separate organizations with different missions, but given our physical proximity, we often work together. This book was our greatest joint venture yet. Staff at both museums provided encouragement as we waded through hundreds of photographs and showed great patience when this book pulled us away from administrative work. But perhaps more than anything, the Peterson and Ronnander families deserve special recognition for providing the support to see this project through. They gave up plenty of family time so we could produce this work. Thank you for understanding.

INTRODUCTION

The lumber industry began in the Northeast in America not long after the first Europeans arrived. By the end of the 1700s, shipbuilding increased the need for logging. In 1790, the Northeast exported 36 million board feet of pine lumber and 300 ship masts. By 1830, Bangor, Maine, was the largest lumber ship port in the United States.

After clearing out the land in Maine, the logging industry pushed westward, primarily into Michigan and Wisconsin. While Michigan logging began in the mid-1800s, the majority of the state's trees were cut down between 1870 and 1890. In 1862, when the Homestead Act was passed, the logging industry encouraged men to claim their 160-acre plots and sell the logging rights to the well-organized lumber companies.

Shortly after logging began in Wisconsin, it continued on into Minnesota. By the early 1900s, most of the forests were devastated in both of those states and the epicenter of the logging industry moved to the Pacific Northwest. In 1905, Washington became the top lumber producer, and in 1926, it produced an all-time record of 7.6 billion board feet.

The Pacific Northwest has continued its domination of wood production. Global wood consumption is rising, and the Resource Conservation Alliance estimates that the consumption will have a 50 percent rise by 2050.

Logging became a major industry in Wisconsin about 1840 and continued until 1910, peaking in 1890. As lumberjacks moved into the Midwest, the larger camps attracted stores, hotels, saloons, churches, feed mills, and eventually, post offices and railroad stations, which led to the creation or expansion of cities including Eau Claire, Oshkosh, Stevens Point, and Wausau.

Wisconsin became a significant player in lumber production. Incorporated in 1844 in Menomonie, the Knapp-Stout & Co. Company became the largest lumber company in the world. Eau Claire had more sawmills than any other city in the world, and Chippewa Falls had the largest indoor sawmill in the world.

The logging industry physically changed the state of Wisconsin. Thousands of acres of trees were cut down, leaving northern Wisconsin strewn with stump-filled lands. Dams and holding ponds were built that redirected the waters of Wisconsin rivers. Villages sprang up to house and support workers.

The logging industry changed the people of Wisconsin. Hardworking men came to Wisconsin from the woods of Maine and Michigan or from a variety of European countries to become lumberjacks. Many of these men settled in Wisconsin and raised families here.

The logging profession changed the economy of Wisconsin. Logging overtook agriculture for a few decades as the dominant financial system in Wisconsin. When the lumber era was over, new uses for the land had to be found. While some dedicated farm families tackled the cutover land, much of it was replaced with trees in the 1930s and 1940s, promoting the growth of papermaking and creating a tourism industry. Both industries remain an important part of Wisconsin's economy today.

In 1852, Wisconsin representative Ben Eastman reassured Congress that the forest had enough lumber to supply America for all time to come. Two years later, the *Wisconsin Pinery* journal in Stevens Point reported that 50 years of logging would "scarcely make an impression on these boundless forests." Sadly, these statements were gross underestimations. In 1840, the census included 124 sawmills, and by 1865, there were 620 sawmills. At that time, the lumber produced was valued at $4.3 million, and by 1890, the value had increased to $60 million. By 1910, the forests were totally ravaged, and it was not until after World War II that they were restored.

Mark Wyman, author of *The Wisconsin Frontier*, sums up the devastation: "Great stumps like bleached skeletons littered the landscape, which supported no trees beyond a few inches in diameter. With much of the forest destroyed and ground cover burned, floods became frequent and large and sudden flows caused year-round river levels to fall sharply. Pine seed supplies declined and white pine blister rust attacked younger trees opening the way for species like aspen. Ecologically, no force since the glaciers has rivaled northern logging in either its immediate or long-term effects."

Logging in Wisconsin explores the 70-year time period when vast forests became cutover wastelands.

One

WHY WISCONSIN?

Wisconsin featured ideal conditions for harvesting white pines. More than 1,000 years ago, ecological conditions paved the way for the growth of extensive white pine forests. Fires burned deep layers in the woods where pine seeds could grow, and the sunlight helped them thrive. By the early 19th century, forests covered five-sixths of northern Wisconsin.

The first Americans to become aware of the forests in northern Wisconsin were those working in the fur trade. By the early 19th century, traders knew that the fur trade was in decline and sought access to stands of timber. However, Dakota, Ojibwe, Ho-Chunk, and Menominee Nations controlled the land and the rivers that could serve as transportation highways for the logs. Potential lumbermen appealed to the US government, and the government worked to acquire Native lands through treaties.

By 1840, Wisconsin had acquired most of the timberlands, and Native people had moved to reservations. The race to extract as much timber as possible was on. Land was cheap, and an acre of forest could be purchased for $1.25. Lands with the stands of white pine, some 200 feet in height and 300 years old, were the most desired of all. The mighty white pine grew straight and sturdy, it was easy to work with, and most importantly, it floated.

Rivers were plentiful in Wisconsin—also a necessity for lumbering in the 1800s. The Wisconsin, Flambeau, St. Croix, Wolfe, Yellow and Chippewa Rivers, as well as smaller tributaries, became logging highways each spring.

Wisconsin was also a destination for those seeking new opportunities. Immigrants from Canada, Germany, Ireland, Poland, and the Scandinavian countries were drawn into the state during the immigration boom of the late 19th century. Many of these families started farms. The established farmers, mill workers, and American Indians were willing to travel to the woods each winter to work as lumberjacks, earning extra money. During the peak years of logging, 115,000 men worked in the forests.

A successful lumber industry needed people, capital, and geological conditions. Wisconsin had all these, and the industry reshaped the entire state between 1840 and 1910.

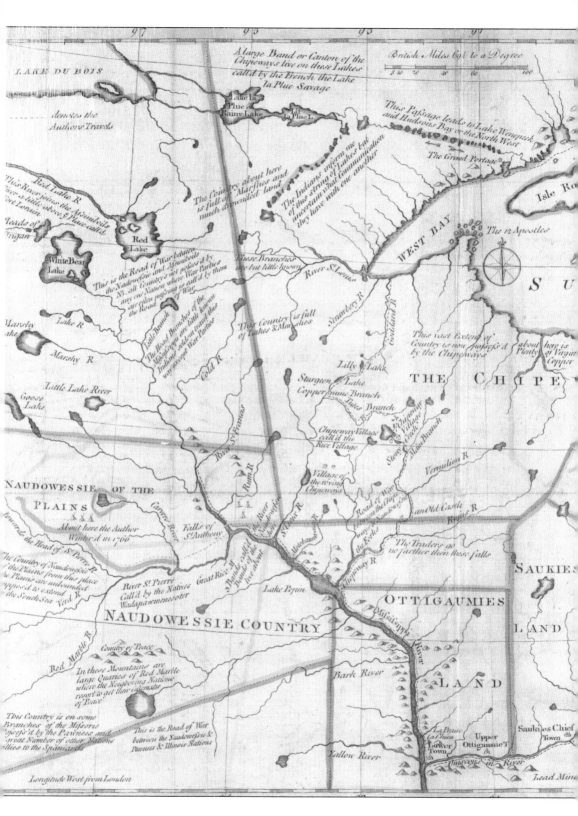

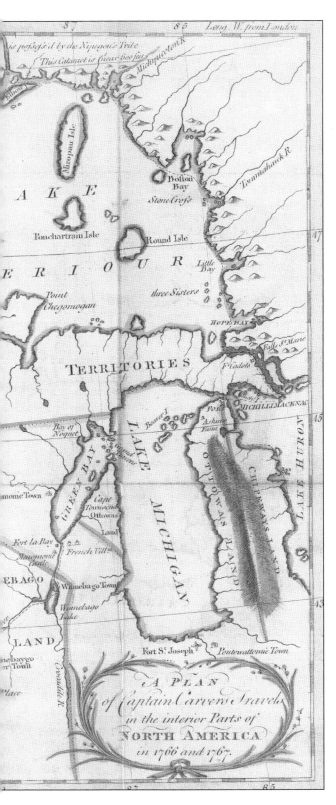

This 1767 map of the Western Great Lakes shows the location of American Indian nations. In 1826, the US government authorized sawmill construction around Green Bay in Menominee territory as long as the Menominee gave consent. This was a policy practiced throughout the state. Americans who tried to log without permission from the Ojibwe, Dakota, Menominee, or Ho-Chunk who claimed territorial rights to the land were harassed and threatened. Some had their sawmills burned down. The 1837 Chippewa Treaty ceded most of the Chippewa and St. Croix Valleys, and logging accelerated after the treaty was signed. Other treaties opened up the valleys of the Wolf, Fox, and Wisconsin Rivers. The map is an illustration in the book *Plan of Captain Carver's Travels in the Interior Parts of North America,* published by C. Dilly of London in 1781. (David Rumsey Historical Society.)

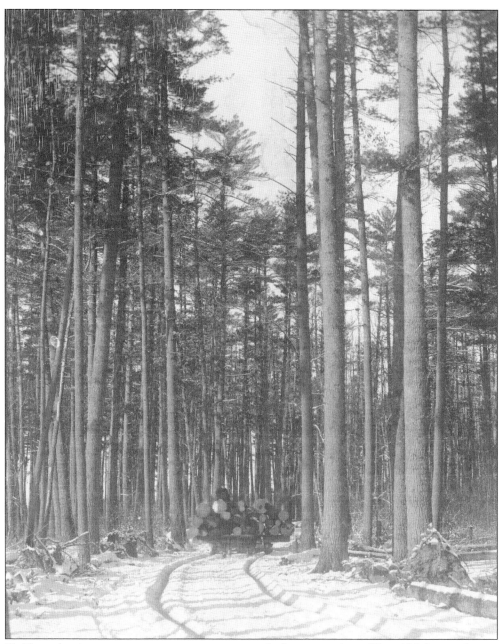

Unlike today, it was not uncommon to see a stand of pines reaching 50 to 100 feet in the air. White pine was valued over red pine because it was easy to work with yet durable and could float. White pine can be identified because its bark is grayish-white in color and the leaves come in bunches of five needles, while red pine is brownish-red in color and the leaves are in groups of three needles. Logs from Wisconsin were used to build structures as far south as Louisiana and as far west as Denver. In the Great Chicago Fire, which burned from October 8 to 10 in 1871, it was estimated that 300 people died, $200 million of damage occurred, and more than 17,000 structures were destroyed. Wisconsin lumber was used to rebuild this part of the city.

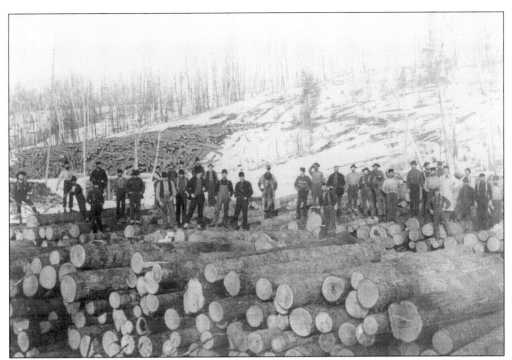

A crew stands on stacked logs at a landing in about 1886. In the background, the hill is stripped of its forest and logs are piled on the ground, ready to be moved to the riverbanks. The logging companies thought they could continue to cut huge amounts of logs for more than 50 years.

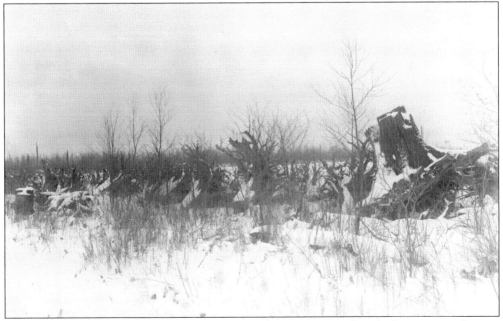

A row of stumps and brush shows the devastation being committed as the loggers moved across the state. The idea of conservation was not discussed. Settlers saw trees as problems to conquer at this time rather than as gifts from nature. Later, farmers would have to deal with these stumps as they tried to cultivate the land for agriculture.

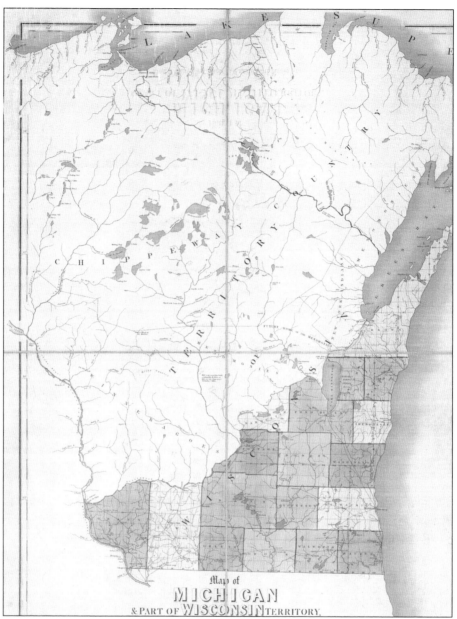

Map of
MICHIGAN
& PART OF WISCONSIN TERRITORY.

This map of the Wisconsin Territory in 1839 shows where the territory has been surveyed. Land once owned by American Indians nations became federal land through the treaty process. In order for the US government to sell federal (public) land to companies and individuals, it needed to divide the land into lots. The Public Land Survey System (PLSS) divided land into six-square-mile townships and one-square-mile sections. The federal government first used this system to survey eastern Ohio beginning in 1785. Crews began surveying Wisconsin in 1833 and gradually worked north and west as more land was acquired from the Native nations. The Wisconsin public land survey was completed in 1866. This map was originally published for John Arrowsmith, London, by David H. Burr in 1839. (David Rumsey Map Collection.)

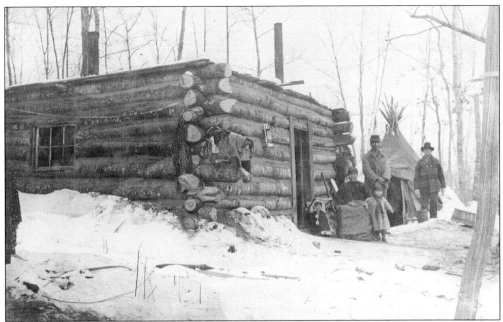

An Ojibwe family is pictured near Big Chetek Lake in 1903. The US government made three land treaties with the Wisconsin Ojibwe Nation: in 1837, the Ojibwes ceded most of their land in north central Wisconsin and eastern Minnesota; in 1842, they gave up the rest of the Wisconsin land; and in 1854, they gave up their land in Minnesota to receive four reservations in Wisconsin. The treaties and reservation removals forced the Ojibwes to adapt a different lifestyle and become more involved in the American economy.

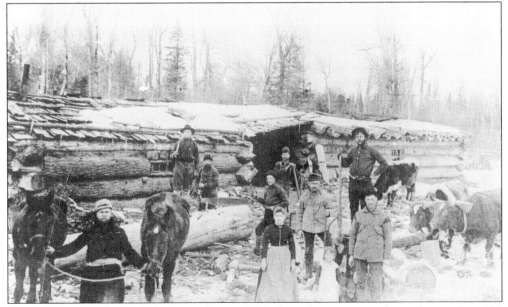

A family poses in front of a logging cabin in 1880. Some logging camps housed more than 100 men, while other camps were run by single families working for larger camps to clear specific areas of woods. Often, the family farmed part of the year, moving to the camps during the winter to supplement their agricultural income.

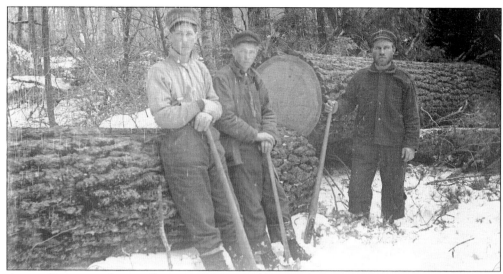

A trio of loggers working in Barronette is pictured here in the early 1900s. The loggers hold their axes and cant hooks, tools used to cut down and move logs. A close look at the logs reveals the size and age of the trees. Lumberjacks are often portrayed as large and strong, but the average logger was 5 feet 4 inches and 140 pounds. (Paul Bunyan Logging Camp Museum.)

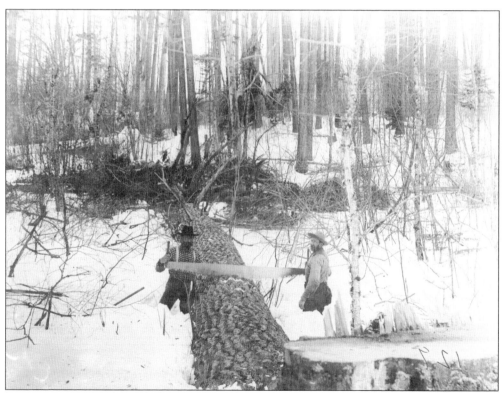

Two sawyers are seen at work about 1905. After cutting down the tree with their crosscut saw, the sawyers remove the limbs and then cut the tree into logs that can be moved out of the forest to the riverbank. In the spring, the logs are pushed into the river for their trip to the sawmill.

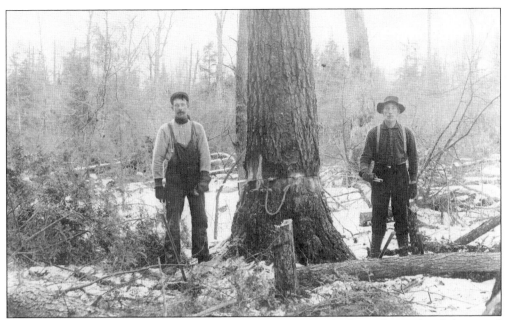

Two sawyers cut down a tree with their crosscut saw. A rope is wedged into the trunk to help control the process. These men most likely were part of the Kaiser Lumber Company, and the photograph is dated around 1908. Loggers often wore wool for warmth and strong, leather boots.

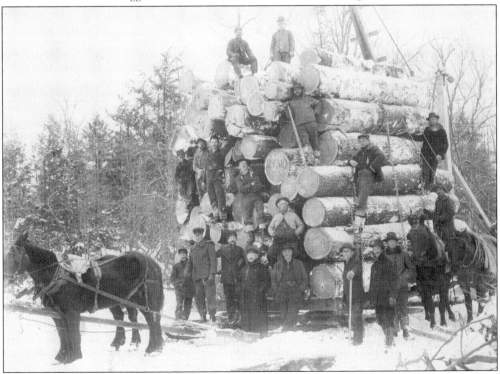

A team of horses gets ready to pull a large load of logs out of the woods. A group of 17 men poses on the logs. The chains help secure the load of stacked logs. Loading logs onto the sled was the most dangerous job in the logging camp.

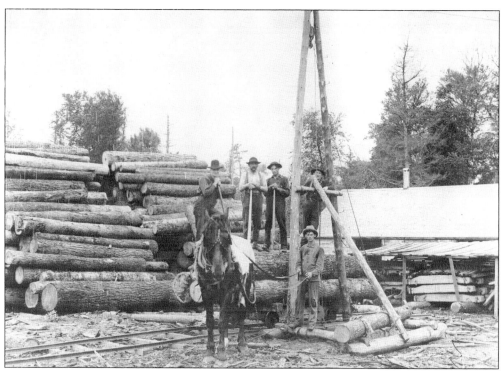

These men are hauling logs on a small tramcar. The wooden piece of equipment is the "jammer." A crew of men would come to camp early to build the jammer. They were the only men who could perform maintenance on the dangerous piece of equipment. Logs would be loaded on the pile or "deck" of the tramcar. This crew was working along the Chippewa River about 1910.

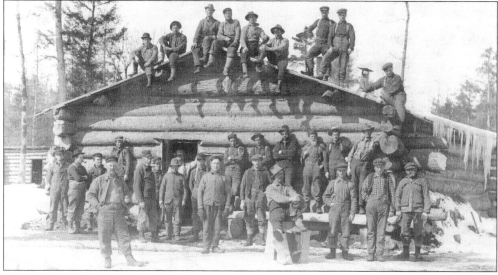

A crew from the Rice Lake Lumber Company near Draper, Wisconsin, poses in 1908. Photographers often came to the camp on Sundays and would take photographs of the loggers posed around the bunkhouse. Men often purchased these images to send home to their families. "Sunday" pictures might also include an overloaded sled that horses never actually pulled but looked impressive in photographs.

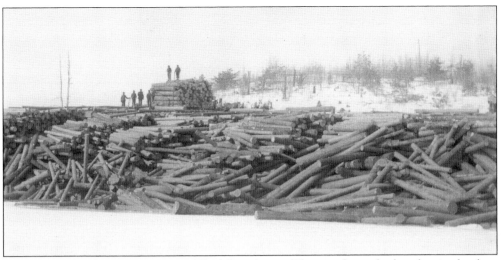

Logs are piled as far as one can see. All of these logs will have to be pushed to the riverbank to get ready for their spring trip. This activity happened up and down the riverbanks after a thaw.

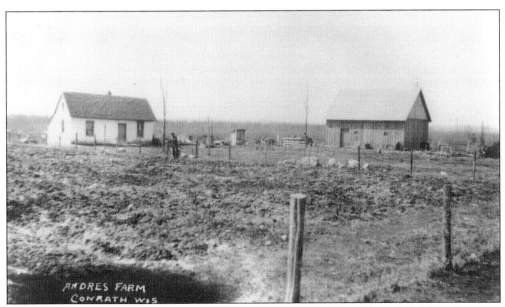

The Andres farm in Rusk County near Conrath, Wisconsin, is pictured in 1948. Many European immigrants came to Wisconsin to farm once the land had been logged. What they thought would be cleared land was often full of brush and stumps. Removing the stumps was backbreaking work. Often, the depletion of trees had driven away animals that the settlers hoped to hunt for food.

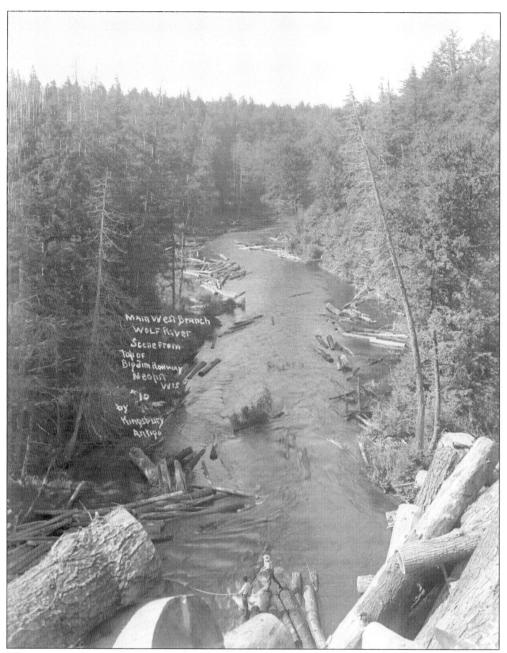

The river crew begins the process of pushing the logs into the river to ride downstream. This is the view of the main west branch of the Wolf River as seen from the top of the Big Jim Rollaway in Neopit, Wisconsin, about 1910. Philetus Sawyer and other Oshkosh lumbermen created the Wolf River Improvement Company to make the river ready for log driving. The company built dams along the river and used dynamite to blow up huge boulders in the river that blocked paths for the logs to travel in. The Wolf River district produced an estimated five billion board feet of lumber between 1835 and 1896. The logs were taken to sawmills in Shawano, Oshkosh, Neenah, Menasha, and New London. (Langlade County Historical Society; photograph by Arthur Kingsbury.)

These men working on the river were photographed by Henry Knapp in 1892. It was a dangerous job; if a man were to fall into the icy, cold water and become trapped underneath a thick group of logs, it would not take long for him to drown. (Dunn County Historical Society.)

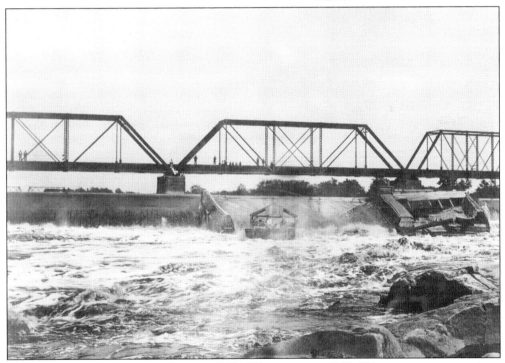

A wanigan runs the falls at Chippewa Falls, Wisconsin, in 1902. Wanigans were sometimes mounted on boats that accompanied the rivermen downriver with the logs. A cook would make the meals on the wanigan, and men often had a place to nap. Traveling with the logs on the river was the most dangerous job in the lumber industry.

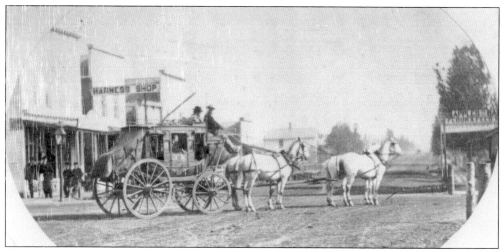

The last stagecoach (part of the William T. Price line) is seen at the intersection of Water and Franklin Streets in Sparta, Wisconsin, in 1863. The stagecoach would be moving on to Black River Falls and then Eau Claire. Men could travel to camps by stagecoach in many areas. Camps could also receive mail by stagecoach.

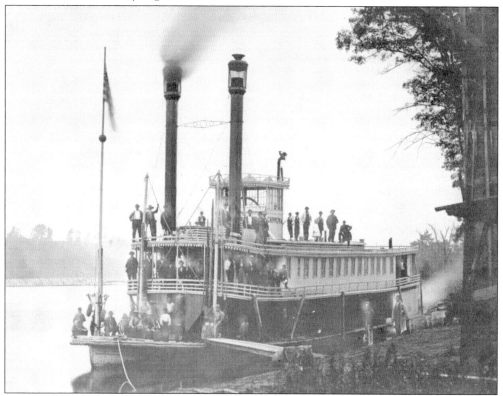

Immigrants traveled on the *Chippewa* steamboat to Rumsey's Landing, Minnesota. Immigrant labor was important to the logging industry. Thousands of workers were needed to fill the logging camp positions every winter. Immigrants who farmed or worked in the sawmills in nice weather would often be willing to work in the logging camps in the winter to earn money to buy land and provide for their families.

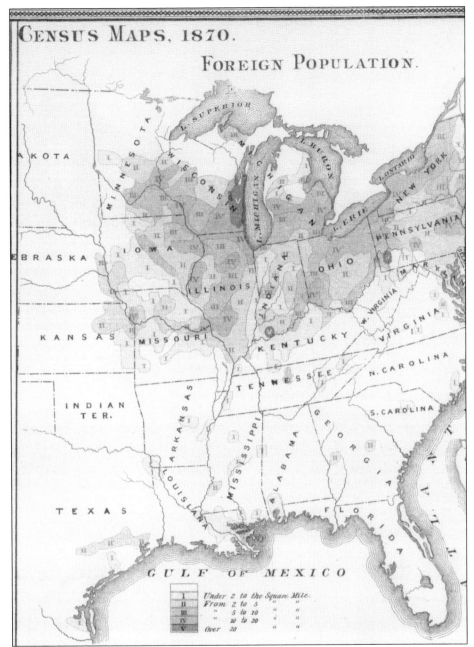

FOREIGN POPULATION.

I	Under 2 to the Square Mile.	
II	From 2 to 5 " "	
III	" 5 to 10 " "	
IV	" 10 to 20 " "	
V	Over 20	

The logging industry demanded a steady supply of workers. Immigrants helped fill this demand. Throughout the 19th century, immigrants from Northern Europe flooded into Wisconsin. By 1870, one-third of those living in logging regions were foreign-born. Although immigrants lived with American-born loggers in logging camps over the winter, they usually preferred to settle next to people like themselves. This created ethnic communities and neighborhoods across the state. Local places like German Valley, Norwegian Valley, and Little Ireland were scattered across the countryside. Within these ethnic neighborhoods, new arrivals could comfortably speak their native languages, attend church services conducted in their native tongues, and practice ethnic traditions. (David Ramsey Map Collection.)

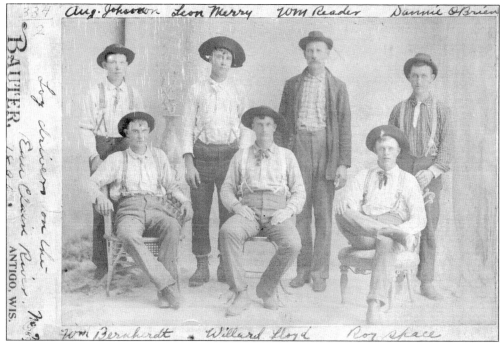

This image of log drivers on the Eau Claire River in 1896 includes, from left to right, (first row) William Bernhardt, Willard Lloyd, and Roy Space; (second row) Augustus Johnson, Leon Murray, William Reader, and Dannie O'Brien. Men from a variety of ethnic backgrounds, including Irish, Swedish, French, and German, bonded in the logging camps. (Langlade County Historical Society; photograph by F.W. Baxter of Langlade County.)

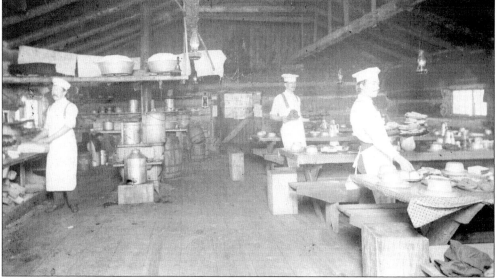

A crew cooks on the landing in 1886. At far left is A.B. Smith, and to the right are Severt Robertson and Sam Robertson, Norwegian immigrants. The crew appears to be delivering a breakfast of pancakes and donuts to the tables while waiting for the loggers to appear for their morning meal. Eggs were called "cackleberries" and biscuits were called "doorknobs." Severt earned enough money working in the woods to be able to open a tavern in Eau Claire.

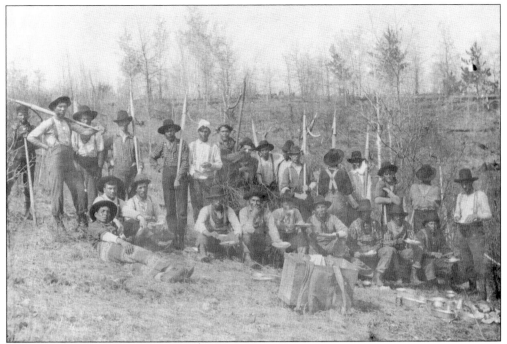

Ojibwe log drivers are at dinner on the Clam River, in Washburn County, in 1901. American Indians were an important part of the workforce in the logging camps and on the river drives. Much of the land that was originally occupied by the Ojibwes was ceded in exchange for reservations and annuities or promises to supply the Ojibwe families with foods and goods for 25 years.

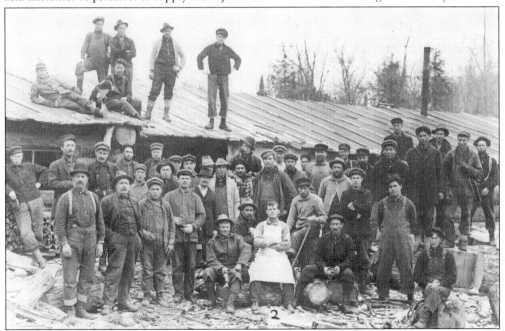

An unidentified lumber camp crew is pictured in front of a log building. Notice the six men posing on the roof with a dog. The date is estimated to be about 1920. The wide variety of ethnic backgrounds and ages can be seen by looking carefully at the wide array of hats and clothing.

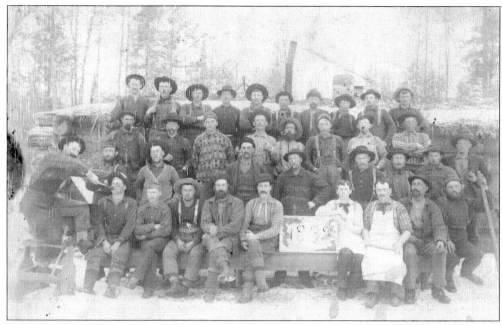

A crew poses in front of a log cabin at an unidentified logging camp with a sign showing the year to be 1892. Although the men have stern expressions, the playful nature of the crew can be seen. Men in the logging camps developed strong bonds eating, working, sleeping, and relaxing together for months at a time.

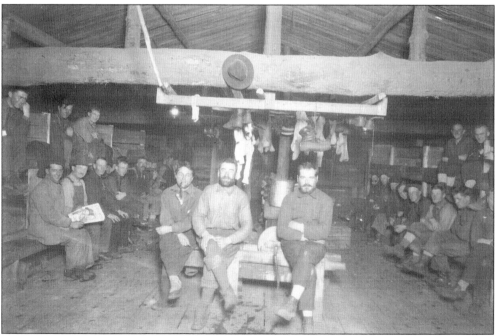

A logging crew poses in a bunk shanty at Camp 10, Hunter Lake, Wisconsin, in 1921. Apparently, these men are happy it is Sunday and they have a day to relax. One can imagine the odors emanating from the wet woolen socks and the sweaty boots hanging up to dry behind the group of men.

Two

The Cast of Characters

The life a lumberjack lived in the woods was backbreaking work and dangerous. Some men moved from state to state, following the timber, spending most of their working lives in the woods. Other men worked in the woods in the winter, and the money they made allowed them to supplement their family income or save money to buy land. A majority of the loggers farmed or worked in sawmills most of the year. Many of the men who worked in the logging industry were recent immigrants from a variety of European countries.

The lumber industry required personnel with a wide variety of skills. Lumber barons bought the land and financed the camps. Foremen ran the camps and hired the men who would spend 24 hours a day, seven days a week together from mid-November until April. A crew came in to clear and grade roads, build the cabins, and assemble equipment. A cook and cookee needed to plan meals for the winter and order the supplies. A blacksmith was necessary to construct and maintain the metal tools. Barn boys were responsible for feeding and grooming the horses. Filers who could no longer endure the harsh conditions in the woods sharpened tools for the crews. Road monkeys worked through the nights maintaining sled trails. The men who went into the woods every day to cut down trees included choppers, sawyers, swampers, and scalers. As logging technology progressed, mechanics and engineers were needed to run steam haulers and locomotives. At the peak of Wisconsin's logging history, 115,000 men were involved in logging.

Many of these men never returned home, being crushed in the woods or drowned in the river. Some men who were able to come home did so without arms or legs due to accidents. Most of the loggers returned home with incredible stories and extra money to help them pursue their versions of the American dream.

The romantic vision of these loggers and the lives they led in the forest fails to take into account the brutal conditions they lived in and the hardships that they faced daily.

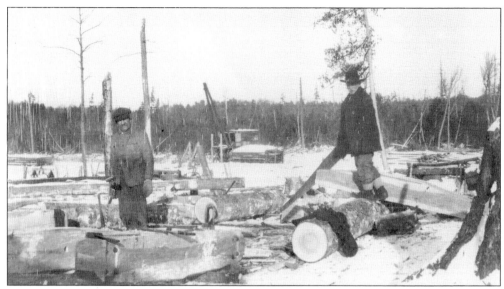

These two "wood butchers" built and repaired logging sleds and other equipment at Camp 4, Rice Lake Lumber Company in 1917. Men often had to improvise when making and repairing tools and machinery, using creative solutions depending on what supplies were available to them. Woodworkers also made and repaired items the cook used on a daily basis.

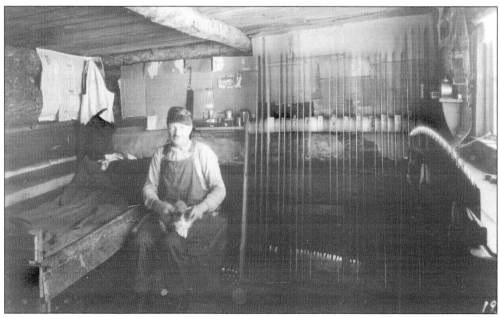

A saw filer works in the filer's shanty at Camp 10 in 1921. Filers were often older workers who could no longer venture out into the woods every day. Often, there were two sets of tools in a camp. One set was out with the loggers and the other set was being sharpened by the filer.

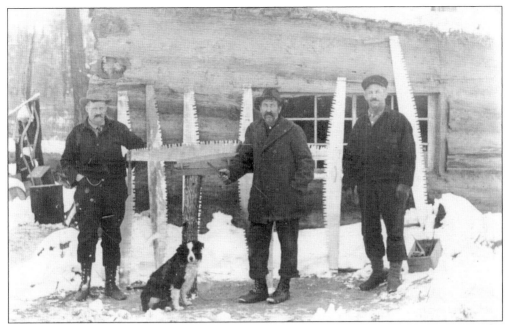

Three filers pause from working on sharpening saws at an unidentified location about 1900. The building behind the men is probably the filer's shanty, which was often a self-standing building in the camp. Keeping the tools sharp was important to continue sawing down trees safely and quickly.

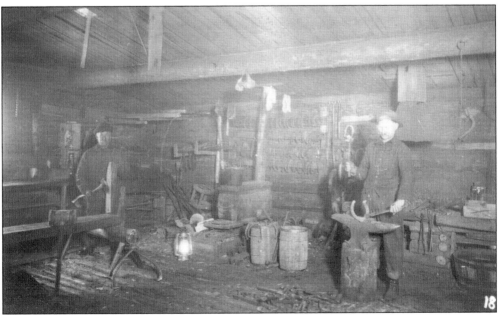

This is the interior of a blacksmith shop at Camp 10, Hines Lumber Company in 1921. Blacksmiths made and repaired the metal items needed in the camp, including tools needed by the cook. Their most common job was making a variety of horseshoes. There were special orthopedic shoes, shoes for working on ice, and shoes for mucky areas to help keep the animal from sinking into the mud.

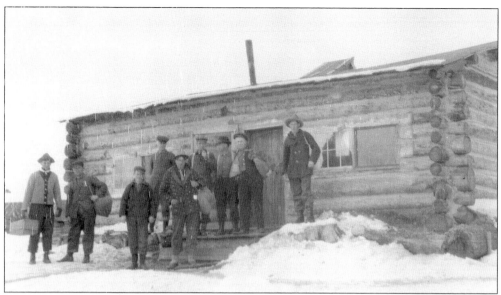

Perhaps these men are arriving at camp with their bundles of clothing. This photograph was taken at Camp 4 of the Rice Lake Lumber Company in 1927. The men would bring their clothes in bundles called "turkeys." It was common for the men to use shirts as pillows at night.

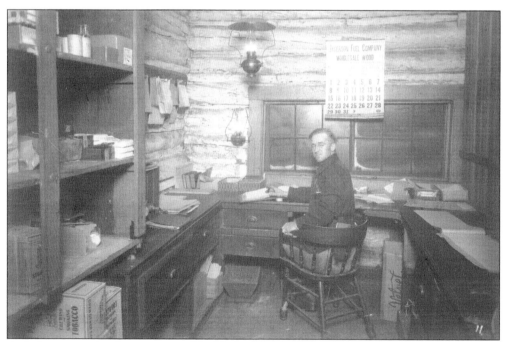

A clerk is pictured at the wanigan at Black Lake Camp, Sawyer County, in 1922. A wanigan often functioned as the logging camp store/post office. A clerk would keep track of the purchases the men made during the season and subtract that amount from their paychecks at the end of the season. Items that were commonly sold can be seen on the shelves in the foreground, including medicine, underwear, and tobacco.

This photograph of three men was taken by Henry Knapp, son of John Holly Knapp, in 1892. John was part owner of the Knapp-Stout & Co. Company, which for a time was one of the largest logging and lumbering operations in the United States. From their expensive fur coats, these three appear to be important men visiting the camp. Perhaps they were on a tour with the foreman. Lumber barons often visited the camp to oversee the work that was being accomplished.

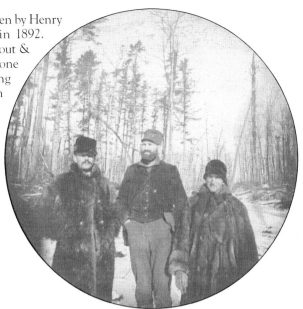

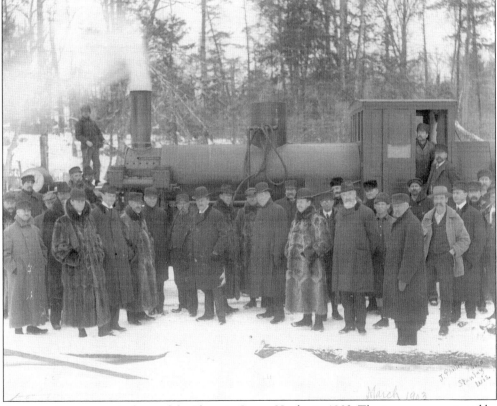

A group of men poses in front of the Phoenix Steam Hauler in 1903. The image was captured by a photographer for the *Eau Claire Leader* newspaper. The coats worn by the men indicate that they are a wealthy group, probably lumber barons excited about the development of the Phoenix. The Phoenix could haul the equivalent of 10 teams of horses.

A crew member is clearing a logging road in 1922. A tote road had to be cleared and graded so supplies and materials could be brought in to build the logging camp. Logging roads also had to be cleared for a path to the river. Roads had to be wide enough to accommodate a sleigh or a sprinkler.

Seen here is the surveyors' and engineers' residence at Camp 3 in the 1920s. The General Land Office surveyors who ranged over Wisconsin between 1832 and 1866 established the township, range, and section grid—the pattern upon which all land ownership and land use is based. Later, survey crews were hired by logging companies to identify property boundary locations and locate other legally mapped features, such as easements for roads or utilities.

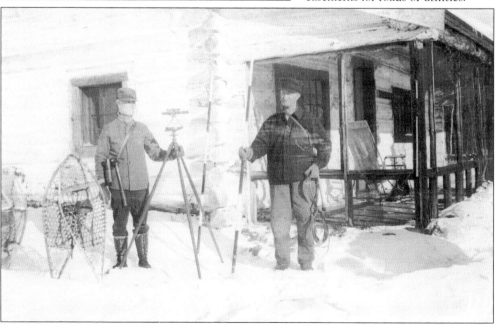

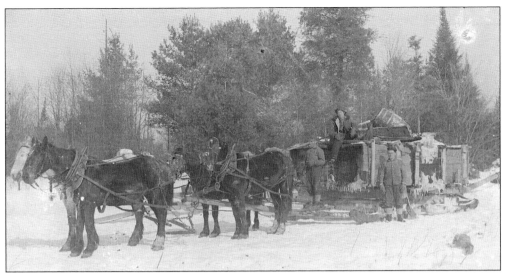

A crew from the Barronette, Wisconsin, area ices the roads, creating new paths for travel for the next day. Water would flow from the barrel, and the rutter would create a grooved area for the sled. Often, the crew would work all night preparing the sleigh paths so log loads could easily be transported from the forests to the riverbanks. (Paul Bunyan Logging Camp Museum.)

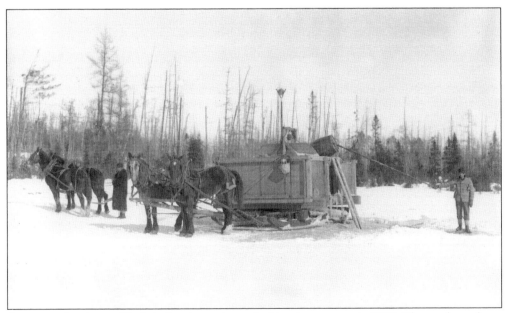

An ice tank is being filled at the river using a decking horse team in 1910. The road monkeys, crews who worked nights inspecting and repairing logging roads, used the barrel to fill the tank with water, and then the holes in the bottom of the tank were unplugged. Water would drip onto a path so the rutter could make a frozen trench. This process created new, clean paths for the sleds to use each day.

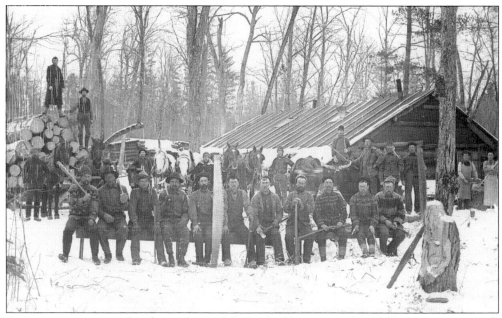

A camp crew is pictured in front of one of the log buildings around 1905. Each man poses with a tool that offers a clue to what his unique job was in the logging camp. Many nationalities were represented in the camps, including French Canadians, Germans, Irish, Scandinavians, Polish, and American Indians, as well as American-born citizens who migrated west looking for opportunities.

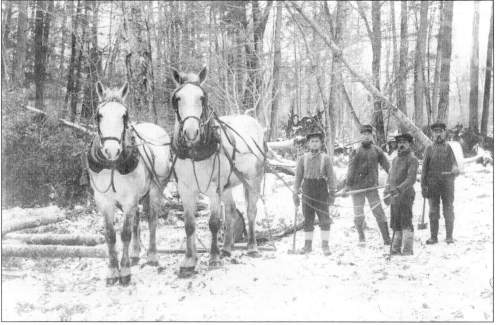

A four-man skidder crew poses with its team of horses. These men are getting ready to skid the logs, which meant moving them from the forest to an area where they could be stacked with a jammer in order to move them by sled to the riverbanks to be stored until spring. These men might be part of the Kaiser Lumber Company, and the photograph was taken between 1900 and 1910.

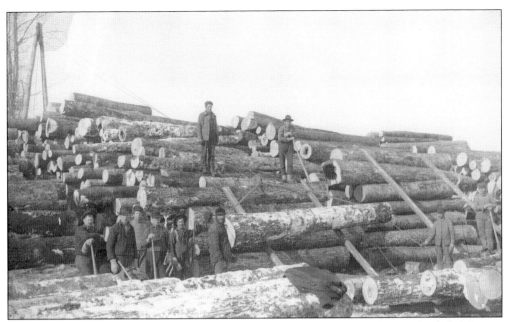

Ten men deck logs at a landing in 1905. The jammer is visible in the background at left. Men are carefully dismantling the logs, shifting them to keep the load even in order not to fall and get crushed beneath them. The men at the top of the pile often wore caulked boots with spikes.

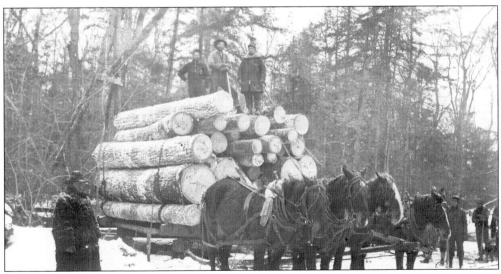

A crew near Barronette, Wisconsin, gets ready to haul a load of logs. Unlike the Sunday pictures' unbelievable loads of logs, this was a typical load that a team of horses would haul to the riverbanks. The man on the left is most likely a foreman. (Paul Bunyan Logging Camp Museum.)

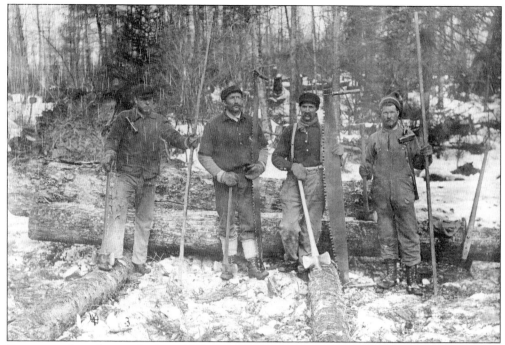

Sawyers work in the woods about 1910. Sawyers were susceptible to injuries. If a sawyer was cut working in the forest, the wound would be plugged with tobacco to stop the bleeding, and if it was severe enough, the foreman would sew the man up once he returned to camp.

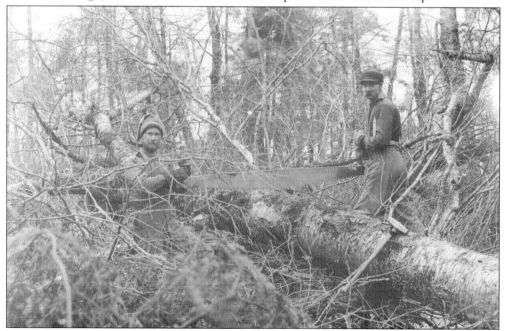

This is an up-close view of two sawyers working on a felled tree with their crosscut saw. This was taken about 1913. A chopper would cut and fell the tree, and then the sawyers would cut the tree into logs. A swamper would round out the crew, and he removed the limbs and cut down any brush that might be a hazard to the horses.

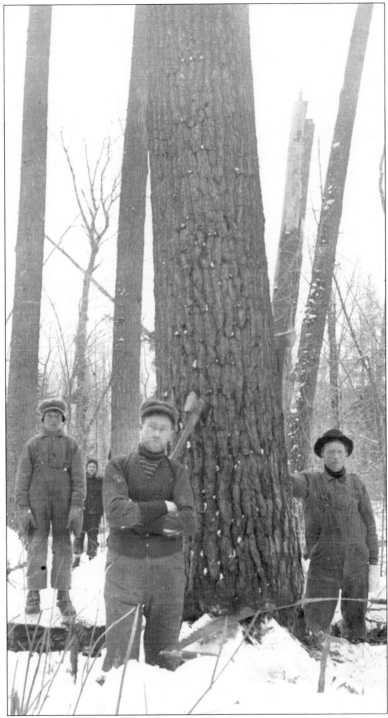

A team of choppers is pictured in the Barronette, Wisconsin, area. To cut the tree, the men notched it with an axe on one side and applied the saw from the other side at an angel a bit above the notch. When the tree fell, it did not hit other trees or leave a "barber chair," which was a huge splinter on the stump. (Paul Bunyan Logging Camp Museum.)

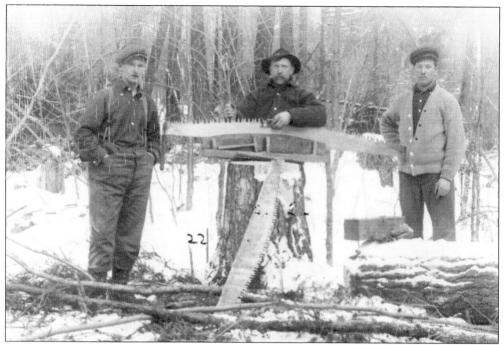

A saw filer sharpens a saw on a stump about 1910. In a 100-man camp, there were 10 three-man saw crews who cut down about 90,000 board feet per day. That number required five skidding teams to move the logs to an area to be loaded, and three jammers could each load 30,000 board feet per day.

This is a saw filer's shack at Camp 10, Hunter Lake, Wisconsin, in 1921. The filer was also called the camp dentist because he worked with "teeth." A filer needed a building with a lot of light. He knew the importance of having sharp tools because he would have worked in the woods at a younger age.

A team of choppers saws the tree with a crosscut saw sometime between 1900 and 1910. The axe was replaced with the crosscut saw about 1890. A raker tooth, used to remove sawdust, allowed saws to be used horizontally. With crosscut saws, the men could fell twice as many trees as a crew with axes.

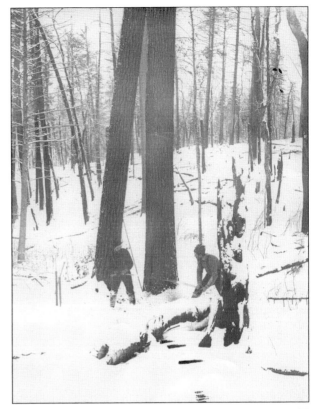

A crew demonstrates the ability of the crosscut saw to cut horizontally. This photograph was taken in Chippewa Falls about 1900 by D.H. Brown. It is either early or late in the season since not much snow is on the ground. Deep snows are why logs were removed immediately once they were cut.

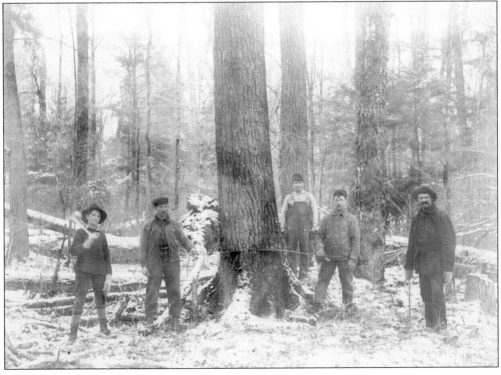

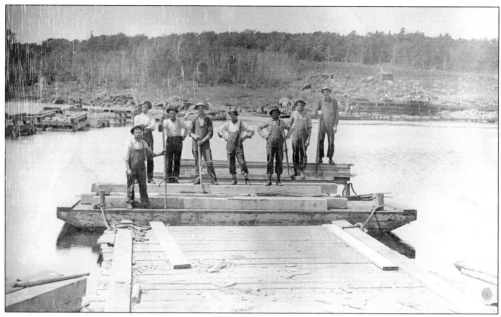

This photograph records the last Chippewa Lumber and Boom Company drive on the Chippewa River in 1906. River driving was a big event, and people lined up along the river throughout the state to watch the lumber as it traveled downstream.

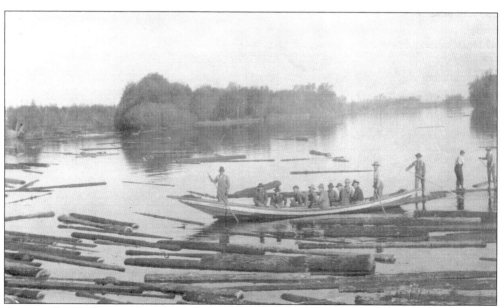

A crew rides in a bateau about 1900. Bateau crews rode with the logs. The bateaux could get in amid the logs to help break up potential logjams.

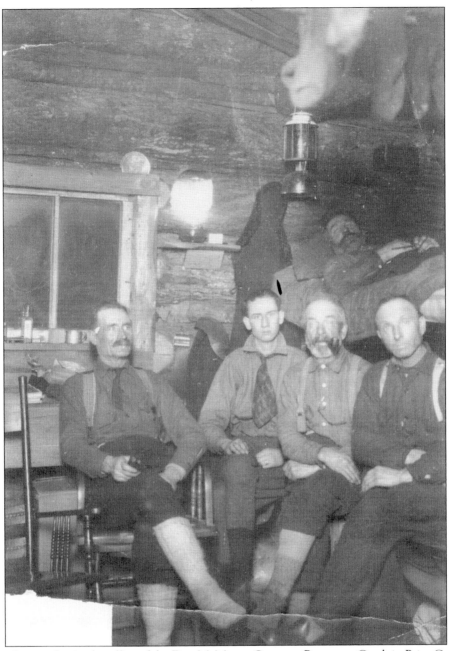

Several men relax in the office of the Dan McManus Camp on Butternut Creek in Price County in 1918. Sitting at far left is George F. Winslow, an Eau Claire druggist who originated the idea of designing a medicine chest with a variety of tonics and patent medicines to sell to lumber camps. There were no doctors in the camps, so men had to treat their own illnesses when possible. Some of the medicines he included were cough remedies, blood purifiers, kidney wines, Jamaica ginger, lice powders, and castile soap. Winslow's chests of medicines were sent to logging camps throughout the state of Wisconsin, as well as Michigan, Minnesota, and Washington. Eventually, he included horse remedies because veterinary visits were not common. In addition to logging camps, his medicine chests were sent to mining camps and railroad-grading companies.

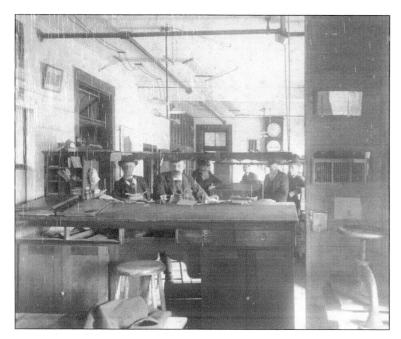

This is an 1892 view of the interior office of the Knapp-Stout & Co. Company, which became the largest lumber company in the world. It began in 1846 when William Wilson and John Holly Knapp bought a sawmill near Menomonie. In 1853, Henry Stout bought into the company. (Dunn County Historical Society.)

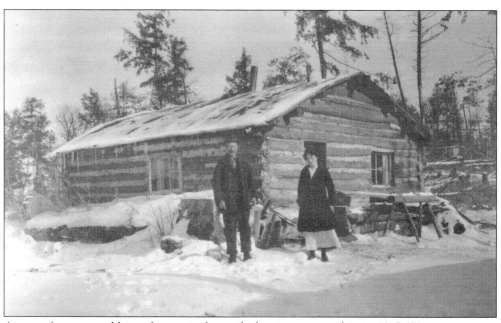

A camp foreman and his wife pose in front of a logging camp cabin in 1915. Women were not allowed in the camps until about 1920. The foreman's wife was an exception, because the foreman often brought his family to live in the camp with him. Sometimes, his wife would serve as cook, depending on the size of the camp.

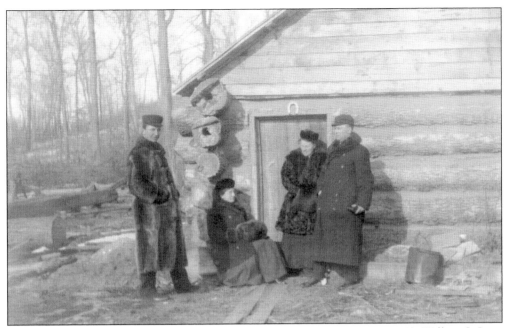

Visitors pose in front of the W.J. Starr Lumber Company Weston Camp in 1907. William J. Starr was born in 1861 and came to Eau Claire, Wisconsin, as a youth to reside with his guardian, Elijah Swift. Starr married in 1886 and, in that same year, along with George Davis, formed the Davis and Starr Lumber Company.

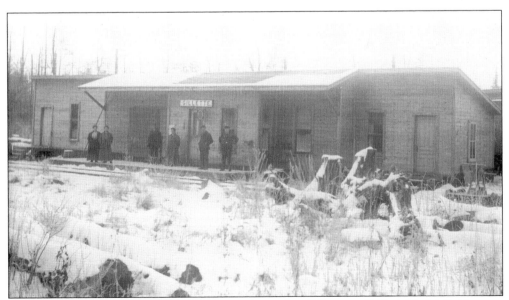

The Dells Lumber Company supply house was located at Gillette in 1910. A Mr. McFadden was in charge of the cabin settlement dubbed "McFadden's Flats," which was located across the tracks. The Dells Lumber Company began in 1868 with the purchase of a small mill. It was incorporated in 1879 with $100,000 in capital and eventually took over the Pioneer Lumber Company.

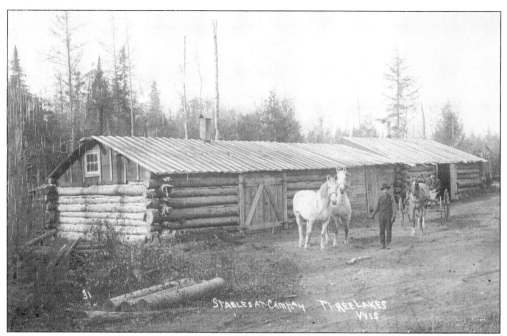

The horse stables at Camp 4, Three Lakes, Vilas County are pictured between 1910 and 1920. If loggers brought their own horses to the camp, the horses made 75¢ a day compared to the $1 a logger made. The foreman had a thermometer in his cabin because if it got too cold, the men went out, but the horses were kept in. (Langlade County Historical Society; photograph by Arthur Kingsbury.)

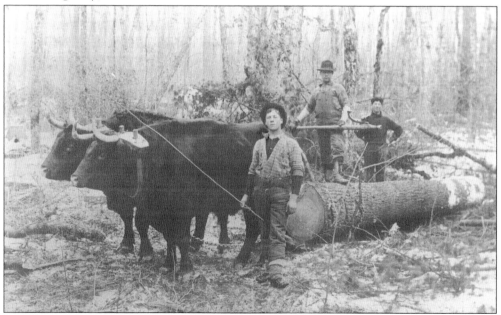

Oxen were used in the camps until about 1890. They were large and powerful, which was necessary to haul the heavy loads of logs. Once the largest trees had been cut, horses became more popular because the breeds had become stronger and they were able to get into areas that were difficult for the oxen to enter.

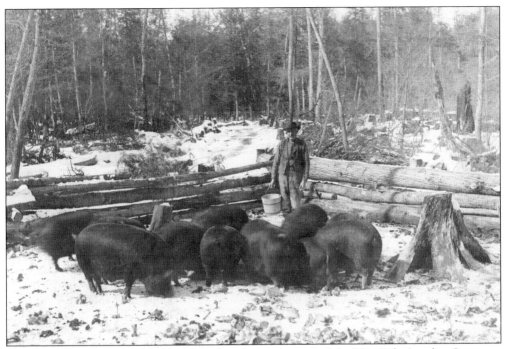

A rare photograph shows a lumber camp hogpen at Camp 4 of the Rice Lake Lumber Company near Draper, Wisconsin, in 1914. Very large camps might have small farms. The village of Prairie Farm started as a farm to feed the Knapp-Stout & Co. Company loggers.

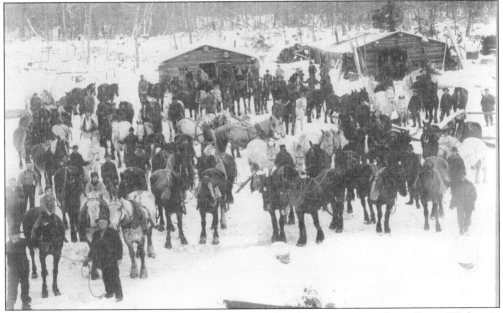

A crew of teamsters is shown in the J.S. Owen Lumber Company camp above Owen-Withee in 1910. Teamsters, affectionately called "dung snuffers" by their fellow workers, owned and managed the teams of horses used in skidding logs, pulling log sleighs, taking the noon dinner to logging sites, and performing other duties around the camp. They were rousted out of bed at 3:00 a.m. for the first breakfast shift. After eating, they went out to feed and harness their horses.

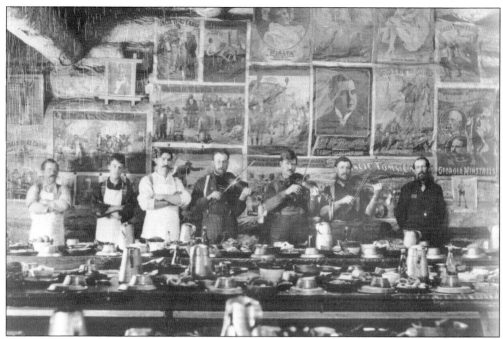

Harmony comes to the kitchen in the August Mason Camp in Brill, Barron County, in 1902. Fiddlers were appreciated by the men, and they played most Saturday nights in the bunkhouse. Music was the "international language" all the loggers understood.

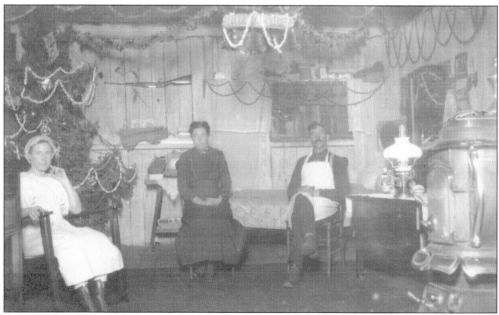

This is a look at the private quarters of a cook at the New Dells Lumber Company, Camp 15 in December 1919. Christmas in the logging camp was not as festive as at home. Sometimes, a tree was decorated and the men had a very nice dinner with extra special desserts. If men chose to work, they could do so for extra money. If not, they enjoyed a day of rest and relaxation.

An ox-drawn sled is prepared to take lunch to the men in the 1890s. The wagon would be lined with blankets to keep the food hot. Sometimes, shelves were built in to hold pies and kettles. If men worked close to the camp, the cook blew a Gabreel horn to call them to lunch. If they were farther away, lunch came to them.

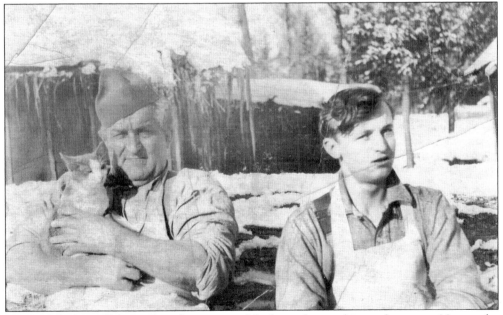

The cook looks gruff, but perhaps his petting of the kitten betrays his gentler nature. Next to the cook is a cookee. The cookee was responsible for hauling water, helping with dishes, preparing food, and keeping the cook shanty as clean as possible. Both the cook and cookee usually slept in the kitchen.

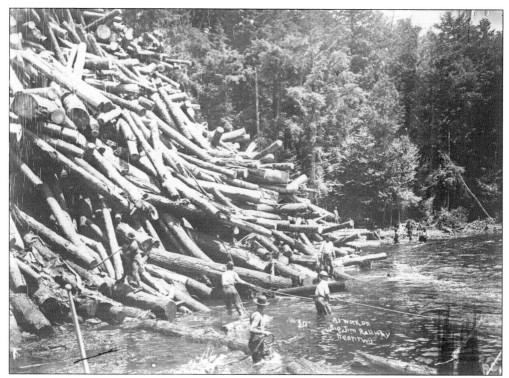

A crew of loggers works to free the logs at the Big Jim Rollaway in Neopit in Menominee County, situated near the Wolf River. Imagine how quickly a man could be crushed if the logs started to create an avalanche of wood. (Langlade County Historical Society; photograph by Arthur Kingsbury.)

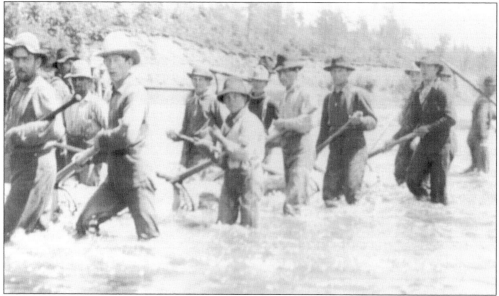

Men from the Knapp-Stout & Co. Company are sacking a log in the river about 1887. The sacking crew searched for logs that were stuck in the river during the drive to the sawmills. The men use their peaveys to help guide the log. (John Russell Collection, Dunn County Historical Society.)

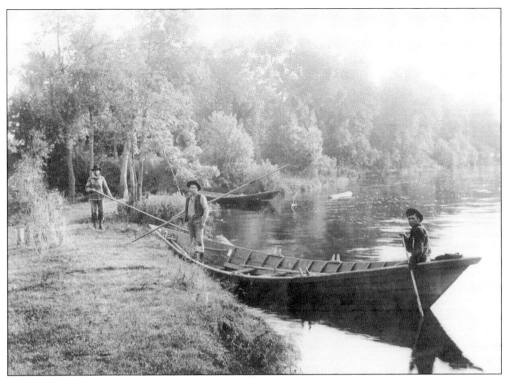

Ojibwe log drivers from the Knapp-Stout & Co. Company pose on the Chippewa River in 1904. The Ojibwes who lived in northern Wisconsin left their reservations to work in the logging camps owned by American businessmen. The Menominee Nation owned the timberlands on its reservation in eastern Wisconsin and operated its own successful sawmill business.

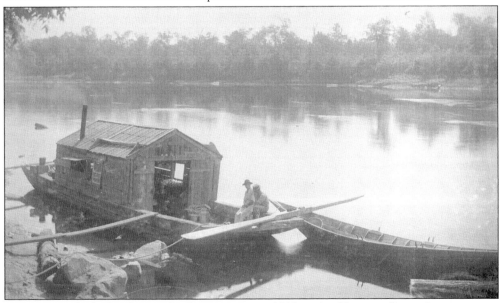

A wanigan is docked at shore with a bateau in tow in 1909 on the Chippewa River. A wanigan was also the logging camp store and post office. The origin of wanigan is from the Ojibwa *waanikaan*, which was a pit or a hole dug in the ground.

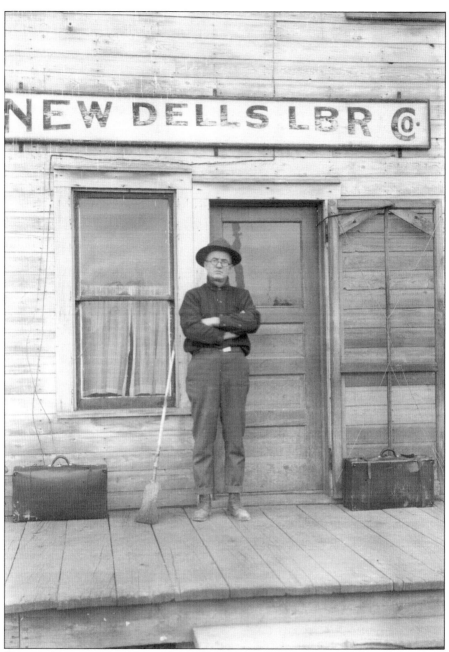

An office employee is seen in front of the office-warehouse of the New Dells Lumber Company, located at Kennedy near the border of Price and Sawyer Counties, in 1924. Office employees often helped sort mail, stock the camp store, and keep track of the men's purchases and earnings during the winter season. By the time of this photograph, 25 families lived in Kennedy and 30 children attended school. The town had been platted in 1908 with the arrival of the Dells Lumber and Shingle Company (renamed New Dells Lumber Company in 1909). Railroad spurs connected the community and company office to seven lumber camps in the woods. The town was short-lived, however, because the lumber company quickly extracted the remaining timber stands, and by 1939, Kennedy was all but abandoned.

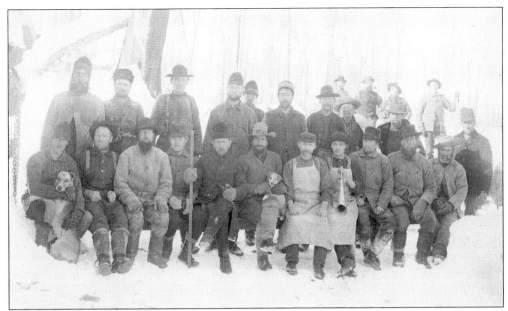

A logging camp crew, along with several dogs, poses for a photographer between 1900 and 1910. One of the cooks is holding a Gabreel horn on this lap, which he would use to call the men to lunch if they were working close to the cook shanty. Notice the variety in the clothing the men wear. Most men wore brightly colored shirts so they could easily be found in the woods if they met with an accident.

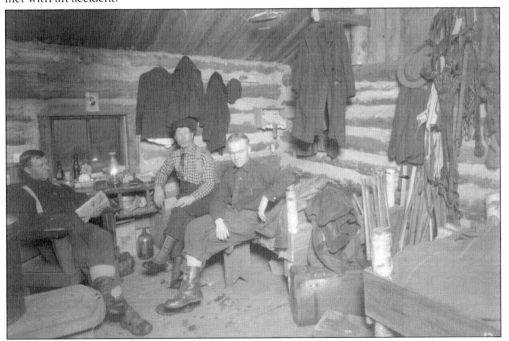

This is an interior view of Camp 10. The young man in the foreground is the camp clerk. Notice the alarm clock on the shelf between the men. Many camps had several alarm clocks to help wake up the men who, exhausted from their daily labor, were hard sleepers. Often, they were up before daylight to get ready for their trek into the woods.

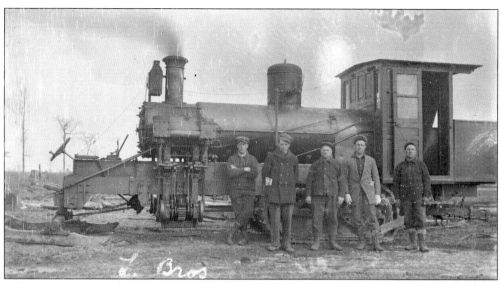

A Barronette crew is shown here in front of a Phoenix log hauler. The Phoenix was an amazing factor in the clearing of the forests. One Phoenix could take the place of 10 teams of horses. When the railroads came to the northern woods and took the place of the Phoenix, the amount of logs that could be taken from the forest multiplied greatly again. (Paul Bunyan Logging Camp Museum.)

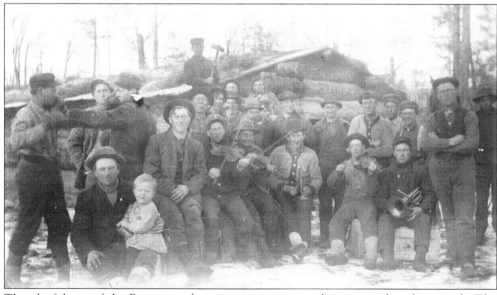

The playfulness of the Barronette logging camp crew can be seen in this photograph. The musicians display their instruments in the first row. Off to the left are two men boxing. A man with an axe overlooks the crowd from above, and the man on the left of the first row, probably the foreman, holds his son. (Paul Bunyan Logging Camp Museum.)

Three

LIFE IN A LOGGING CAMP

Men worked and lived in the logging camps from mid-November until the beginning of April. Because the trees were so large and the leaf canopy so thick, sunlight could not penetrate very well, and the ground was mucky most of the year. Once the ground froze, the heavy sleighs could traverse the paths with loads of logs.

The men developed strong bonds working, eating, sleeping, and playing together. Working for $1 a day ($1.50 if one were a clerk or a cook), the men endured rough living conditions. Although food was usually good and plentiful, the men had to eat quickly and quietly. They arose about 5:00 a.m. and worked until dusk. Injuries were common and insurance was not. Sunday was their only time to relax. In addition to resting, any bathing, clothes washing, or mending that was needed had to be accomplished on Sundays as well. Bathing was surely not done often enough—men hated to waste a free day heating water and scrubbing, and they feared bathing too often in the winter could lead to pneumonia.

Louis Blanchard, a logger in Chippewa Falls for most of his life, described the odor of the bunkhouse: "Along the sides there was a lot of racks to hang socks and clothes on to dry at night. Everybody's got wet from the snow every day and we needed a lot of racks for drying. When the socks began to send off steam at night, you sure knowed you was in a logging camp. When you mix the smell of wet socks with the smell of baked beans and chewing tobacco, you have a smell that a lumberjack never forgot." Add the smell of unbathed men, sweat, lack of toilet paper and restrooms, and stale air, and imagine the stench that men slept through.

Life was not easy in a logging camp, but men were grateful for the extra money they were able to make to help purchase land and take care of families. The loggers got along remarkably well, given the variety of personalities that were forced to spend time in cramped quarters for months of the year.

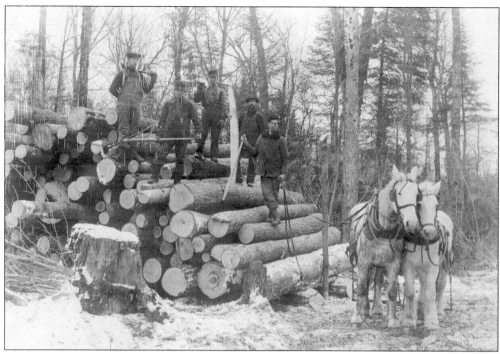

The crew came into the camp in winter because the trees were so thick that the ground stayed muddy and mucky the rest of the year. It was said trees were so plentiful in northern Wisconsin, squirrels could hop from tree to tree without touching the ground.

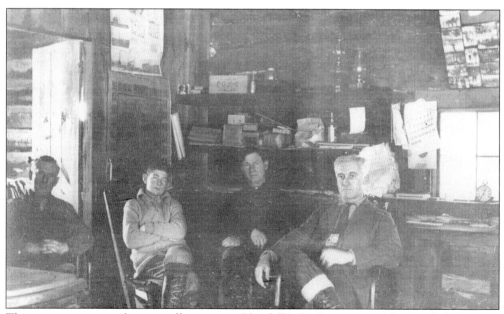

This rare interior view shows an office scene at Blaisdell Lake Camp, part of the Rice Lake Lumber Company in 1912. From left to right are T.E. Branham, Roger B., William Bartlett, and Rev. A.E. Leonard. Several of these men are visitors, who were only allowed at the camps on Sundays when logging was not taking place.

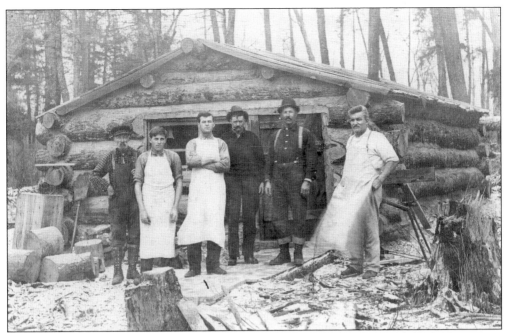

Three cooks pose in front of a cabin with several other camp employees. While the loggers got $1 a day, cooks got $1.50 a day. There were several reasons for this: if the food was good, men wanted to work at that camp, and secondly, the cook never got a day off.

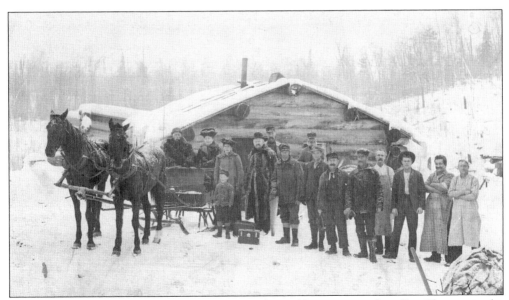

Visitors arrive at the camp. Oluf Sherman, a jeweler and businessman from Eau Claire, is in the fur coat. Ole and Gunnhild Emerson from Chippewa Falls are in the sleigh. The cooks and other employees pose with them. Typical visitors who came to the camp on Sundays included families, insurance salesmen, and traveling preachers.

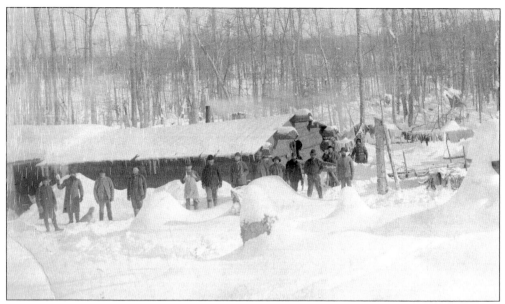

A small lumber camp crew poses in the snow between 1900 and 1910. Deep snow could cause problems for the camps, making it impossible to get to the woods or transport loads of logs. Two split pine logs put together in a "V" shape made a plow for the roads.

These camp buildings were part of the Hines Camp in Winter, Wisconsin. Most camps were built to only last a season or two. Moss and mud were used for chinking, and it often fell out, leaving gaps for cold air to enter. After one or two winters, camps were abandoned, leaving small ghost camps scattered across Wisconsin.

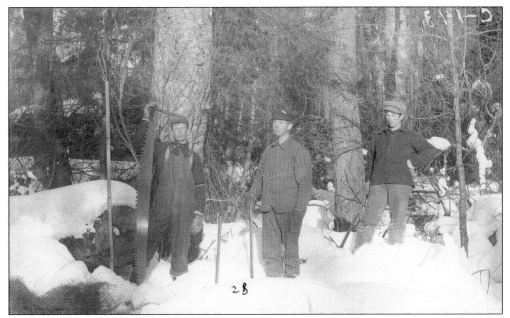

A trio of loggers display their tools, including a saw and a measuring stick, in 1913. The most common scale sticks included the Minnesota Standard, the Wisconsin Dismal C, and the Doyle. Wood was measured in board feet, a board foot being a board 1 inch thick by 12 inches wide by 12 inches long.

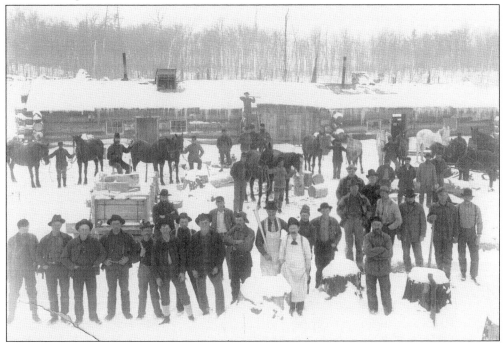

A large group of logging camp employees and horses poses in front of a building between 1910 and 1920. The foreman took great pains to ensure that the men got along for the four months they were working in the camps. Alcohol was forbidden, as was gambling or any activity that could lead to an argument.

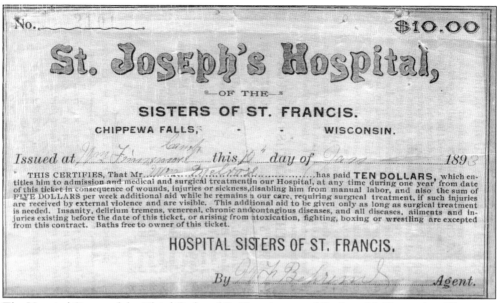

No. _____ 2161 _____ **$10.00**

St. Joseph's Hospital,

—OF THE—

SISTERS OF ST. FRANCIS.

CHIPPEWA FALLS, - - **WISCONSIN.**

Issued at *Wm Timmerman Camp* this *10* day of *Jan* 189*3*

THIS CERTIFIES, That Mr. *Wm Kjelstad* has paid **TEN DOLLARS**, which entitles him to admission and medical and surgical treatment in our Hospital, at any time during one year from date of this ticket in consequence of wounds, injuries or sickness, disabling him from manual labor, and also the sum of **FIVE DOLLARS** per week additional aid while he remains in our care, requiring surgical treatment, if such injuries are received by external violence and are visible. This additional aid to be given only as long as surgical treatment is needed. Insanity, delirium tremens, venereal, chronic and contagious diseases, and all diseases, ailments and injuries existing before the date of this ticket, or arising from intoxication, fighting, boxing or wrestling are excepted from this contract. Baths free to owner of this ticket.

HOSPITAL SISTERS OF ST. FRANCIS.

By *Wm F Behrend* _____ *Agent.*

The Hospital Sisters of the Third Order of St. Francis opened St. Joseph's Hospital in Chippewa Falls in 1885. Insurance tickets to loggers helped fund building additions to the hospital. Insurance tickets covered one year's worth of medicine and inpatient care at any of the 11 hospitals run by the Sisters in the Midwest. A logger could also order medicine while at camp as long as the order was signed by his foreman.

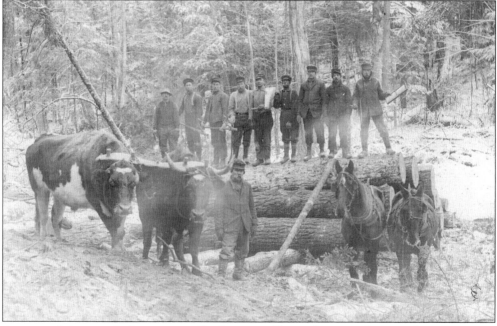

An unusual photograph shows teams of both oxen and horses being used to move logs. Oxen were used in woods with large trees because they were cheaper to buy and maintain, they worked one-third longer than horses, they needed no grain, and they could start work at a younger age than horses; also, the yokes could be made by hand, while harnesses were expensive to purchase.

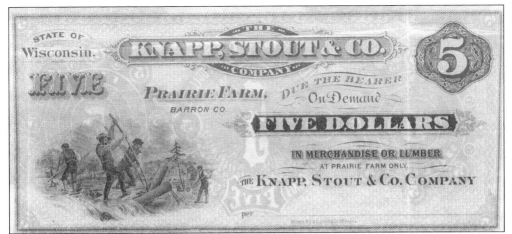

This is an example of currency from the Knapp-Stout & Co. Company in Menomonie in the late 1800s. Many items could be bought in the logging camps while the men were working in the woods. Items men often purchased incsluded clothing; medicine; games, such as checkers; musical instruments, including harmonicas; and personal items, including toothbrushes, soap, and tobacco. Camps usually charged fair prices—things were not marked up.

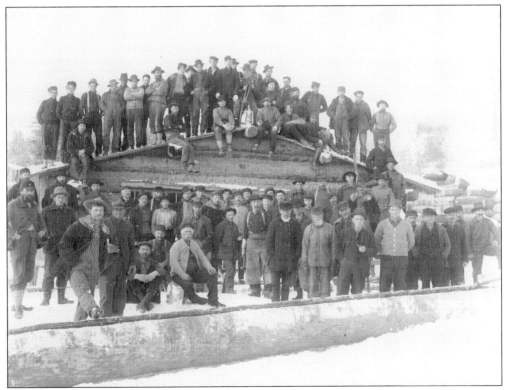

A large logging camp crew from a camp above Owen-Withee poses for a photograph between 1895 and 1910. Early camps were often limited to one or two buildings. After 1875, camps became larger and more elaborate. The bunkhouse became a separate building, stables were added, and a wanigan and a blacksmith shop were included, as was a filer's shanty.

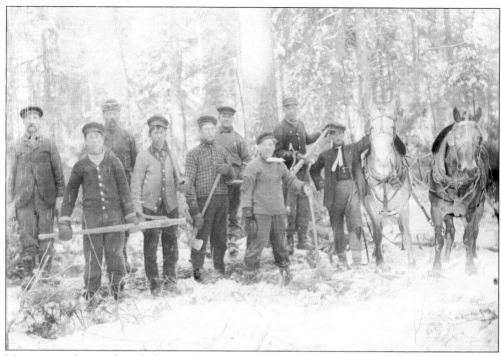

Men pose in the woods with their tools in this photograph taken between 1900 and 1910. Despite the differences in their clothing choices, most men wore long wool underwear, wool socks, warm boots, mittens made of wool or deer hide, and felt hats. When these items needed patching, the men took time on Sunday to mend socks and darn mittens.

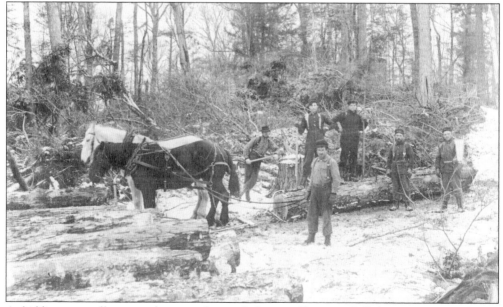

A skidding team of horses and men works at a skidway in Chippewa Falls between 1900 and 1910. The photograph was taken by D.H. Brown. A skidding tong is used to haul the log. The skidding tong was actually an improvement of a basic ice tong—it was hooked into a log like tongs around an ice cube—and the harder the horses pulled, the more firmly the log was held.

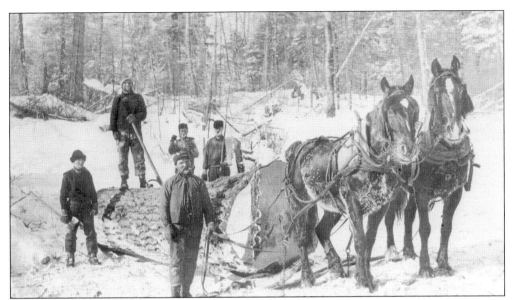

Here is an example of the enormous logs that were being cut down in Wisconsin in the mid to late 1800s. A five-man skidding crew moved the logs from the forests to an area where they could be loaded on sleds. Leather boots were replaced after 1880 by the quarter boot, a rubber shoe that fit snugly below the ankle worn with two pairs of wool socks.

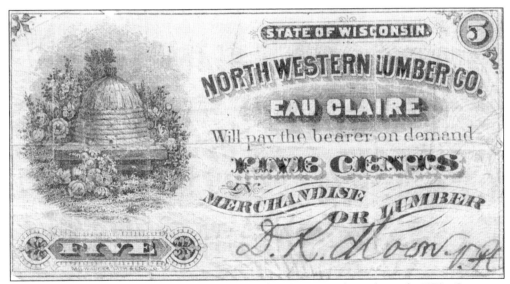

Shown here is scrip from the Northwestern Lumber Company from the early 1870s. Scrip was used in the wanigan or camp store to buy items. Here are some sample costs of items about 1870: extra heavy wool socks, 33¢; toothbrush, 6¢; pine tar soap, 5¢, folding chess/checker board, 8¢; a set of checkers, 20¢; a set of chess pieces, 45¢; cough syrup, 30¢; and a violin with bow, resin, and strings, $3.

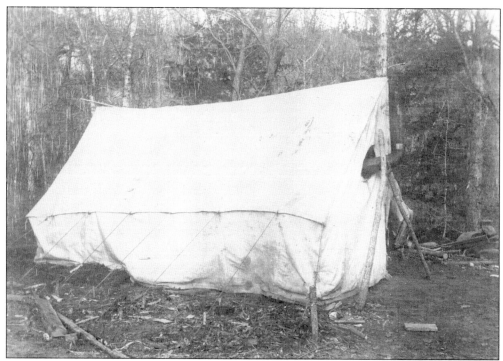

Smaller camps might use a tent for the cook rather than a more spacious cook shanty, especially if the crew was only one family. While there were many similarities among camps, it was said that "if you've seen one logging camp, you've seen one logging camp." There were many variations depending on size, available cash, and expertise of the crew.

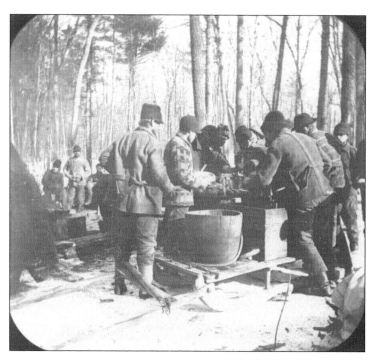

Men of a Knapp-Stout & Co. Company crew eat their lunch in the woods in 1892. A typical lunch might consist of stew, roast beef sandwiches, baked beans, potatoes, pies, and, with every meal, prunes and hot tea. Midmorning and midafternoon snacks were also taken to the men while they worked in the woods.

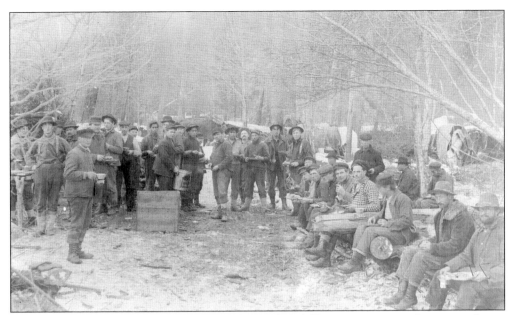

A crew takes a break to eat lunch between 1900 and 1910. From time to time, the men might get a special treat for lunch or dinner. One special meal was "Lumber Camp Boiled Dinner," which consisted of 2 hams, 12 onions, 4 rutabagas, 3 cabbage heads, 20 pounds of carrots, 50 pounds of potatoes and salt, pepper, and bay leaves.

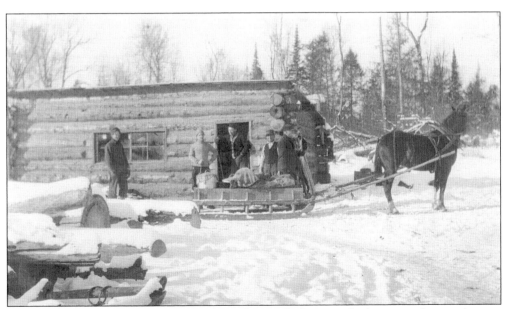

The cook is ready to take lunch or snacks to the woods. Because the living conditions, sleeping conditions, and work conditions were the same from camp to camp, having good food was a way to ensure being able to hire a strong, hardworking crew. A bad cook was called a belly robber.

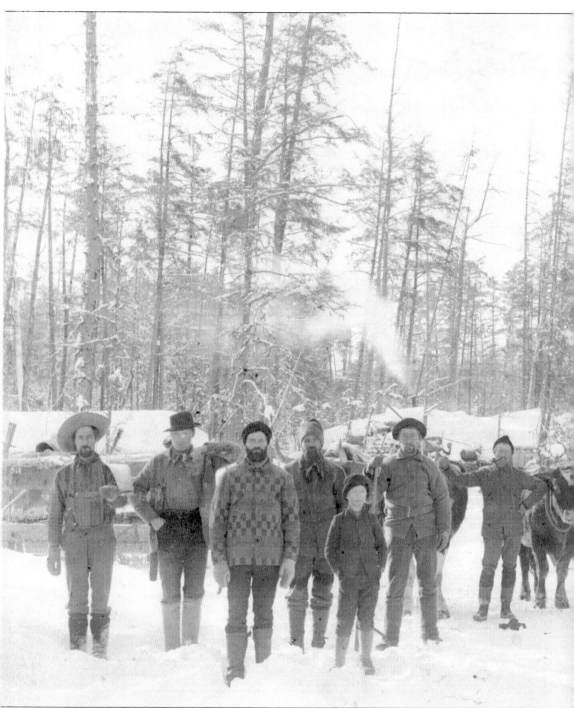

A crew with horse-drawn sleighs, logs, and tools takes a break at the Emerson Camp in Lublin, Chippewa County, Wisconsin. A smaller crew was common at camps before the 1880s. After that time, the crosscut saw became the tool of choice for cutting down trees, and the demand for wood increased dramatically across the country, due to the Great Chicago Fire and westward expansion. Larger crews were hired because two men could cut faster, which meant more logs

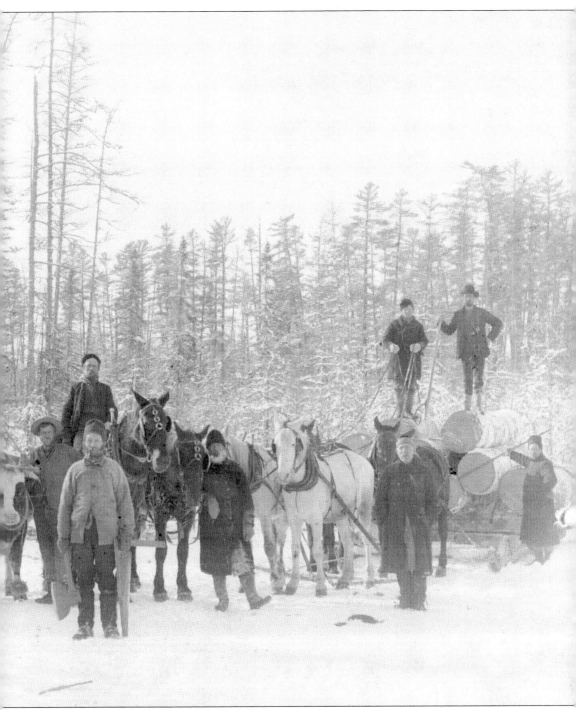

had to be hauled away faster. Larger breeds of horses like Clydesdales and Percherons became available, and they were strong enough to haul large loads, but they could still navigate spots in the woods that were too hard for larger oxen teams. Once railroads began building tracks in Wisconsin, logs could be cut down much farther from rivers, because horses were limited to about a six-mile trip when hauling heavy loads.

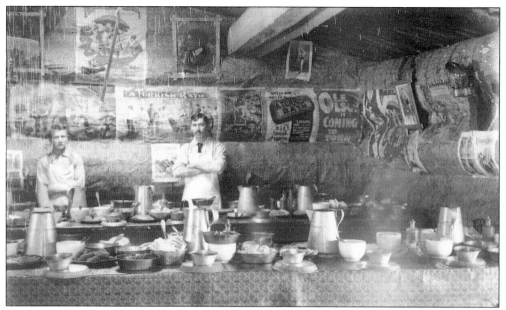

A cook and cookee are seen in a cook shanty from 1905. The cook and cookee had to be up by 4:00 a.m. to prepare breakfast, and they continued working hard preparing lunch, two snacks, and dinner for a logging camp crew. Because they worked in the cold, loggers ate about 8,000 calories a day.

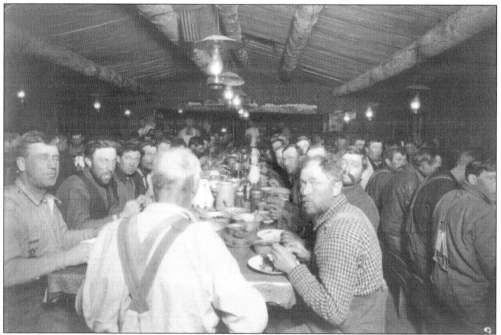

A cook shanty is set to serve loggers coming in for a meal in 1921. After 1900, loggers drank coffee—and lots of it. The three-gallon coffee pots, which doubled as coffee makers, served four to six loggers apiece. The recipe for boiled coffee is as follows: fill the coffeemaker with water and one and one-half cups of coffee grounds, bring the mixture to a hard boil, and then throw in eggshells to settle it before serving.

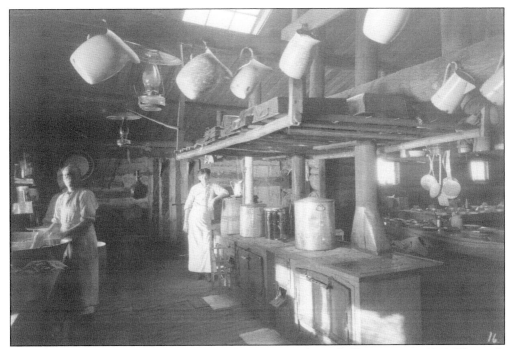

This is an Arpin Lumber Company cook shanty in Birchwood, Wisconsin, in 1911. The cook had to plan the food needs for the entire winter and order supplies before arriving at the logging camp. If he ran out of food staples, there was no local grocery store to run to.

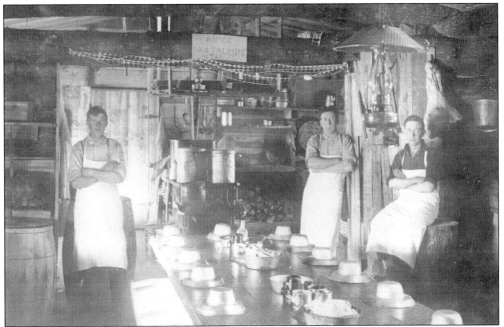

Note the "No Talking" signed posted in the all-cook shanty. The men had to remove their hats to show respect for the cook, they were not allowed to talk unless asking for more food, they had to wait to leave until everyone was done eating, and if they did not finish the food that they took, they often had to eat that food at the next meal.

Pictured is the interior of a log stable at a logging camp in 1917. Horses needed to be sheltered from the harsh winters, so every camp had stables. The stables were as makeshift as the bunkhouses. Barn boys cleaned the stables, if the camp was large enough to employ barn boys. Sometimes, itinerant photographers visited the camp

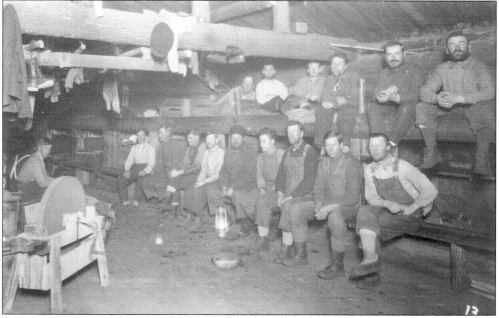

This is the inside of a bunkhouse at Hines Lumber Company in Draper, Sawyer County. Lice and fleas were common problems in the bunkhouse. To get rid of them, men boiled their clothes, burned blankets, replaced pine boughs as mattresses, and rubbed tobacco or camphor oil on the sleeping materials.

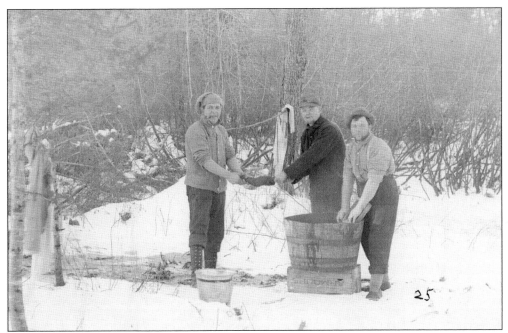

A trio of men tackle their Sunday washing in 1913. Washing clothes was an all-day event. Water had to be hauled and boiled, and clothing was scrubbed and rinsed. Items then had to be hung up near the stove to dry for the next day's work. Bathing was also not popular, occurring about every three weeks.

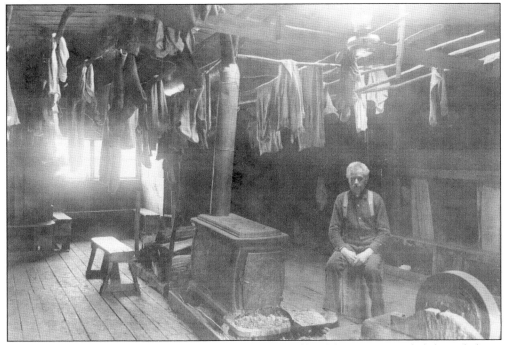

This is a typical bunkhouse in 1915. A stove in the middle of the room provided the only heat, while ice appeared on the outside walls. Lots of hanging racks held wet and sweaty clothes. The grinding wheel in the right foreground was used by the men to sharpen their axes.

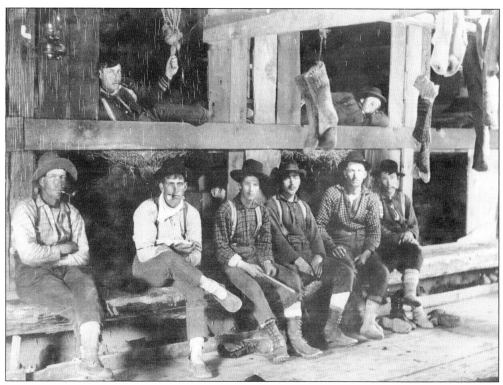

Upper and lower bunks are pictured in a bunkhouse in Hayward. The men were able to sit on the deacon seats. Two men shared each bunk. The straw is visibly coming out of the upper mattresses; it helped keep the men warm and could easily be burned and replaced when it became "buggy."

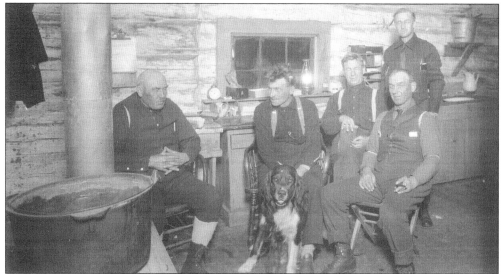

Several men relax in a bunkhouse at Camp Three, Blaisdell Lake, which was part of the Rice Lake Lumber Company in Draper, Sawyer County. From left to right are a scaler, a foreman, William Bartlett, a visitor, a walking boss, and the clerk stands. The photograph was taken between 1910 and 1920. Bartlett wrote many historical articles about the Chippewa Valley, including its logging industry.

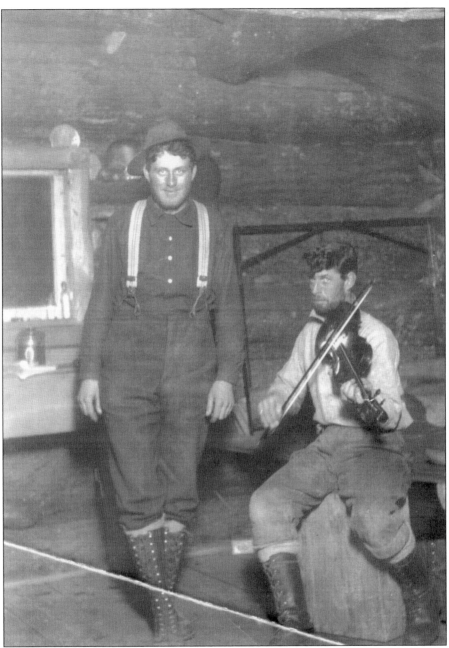

A camp fiddler and jig dancer perform at a Park Falls Lumber Company camp. Sunday was the one day men did not have to get up early to head into the woods, so Saturday night in the bunkhouse was a time for the men to relax. Because there were so many different nationalities represented, music was a way to bring the men together. They sang songs such as "Peggy Gordon," "Barbara Allen," "Annie Laurie," and "Shantyman's Song." Playing the fiddle, violin, or harmonica was common. Sometimes, half the men would place bandanas in their back pockets and become the "women" in order to dance to the music. Games like checkers or chess were often played as well. Storytellers were always popular. Men began telling stories about an unusually tall French Canadian, Paul Bunion, which turned into the tall tales about Paul Bunyan and his blue ox Babe.

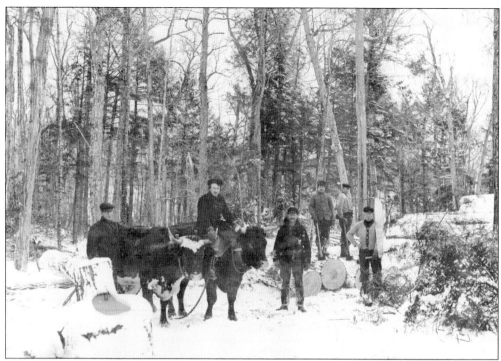

A group of skidders and oxen is pictured at Jack Ryan's Camp near Draper, Wisconsin, in 1908. The foreman told the men where to log daily based on a timber cruiser's crew report. Before the camps were built, a timber cruiser crew consisting of an appraiser, a compass man, and a cook conducted a survey on the best area to cut trees. Millions of dollars depended on their assessment.

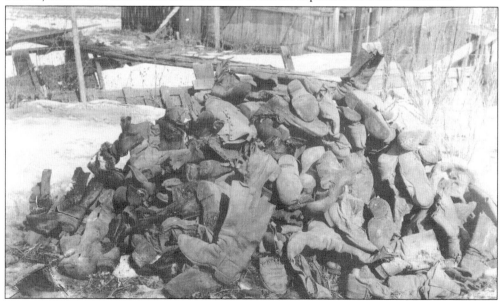

Perhaps nothing shows the end of the logging era as poignantly as this pile of lumberjack boots found at an abandoned camp. The Paul Bunyan Logging Camp Museum in Eau Claire, which opened to the public in 1934, obtained many of its original artifacts from abandoned camps throughout central Wisconsin.

Four

TOOLS OF THE TRADE

When people imagine 1800s lumberjacks, the first picture that usually comes to mind is two men cutting down a tree with a crosscut saw. While axes and saws were used throughout the history of logging, they were improved and upgraded significantly between 1840 and 1910. Many tools were improvised by men from necessity in the woods when unplanned needs arose. In addition to the axes and saws, a variety of equipment was essential for life in the woods working with logs.

This chapter looks at the heavy equipment such as jammers, rutters, and sprinklers. Smaller, yet significant, tools will also be examined such as cant hooks, chains, go-devils, peaveys, and scaling sticks. The chapter also discusses why camps moved from oxen to horses and how the railroad industry benefited the logging operations.

Oshkosh Tools began in 1887 to furnish logging corporations with the tools they needed to get the job done. Still in business today, the company is well respected for its high-quality products.

The first sawmill in Wisconsin was built in DePere in 1809. In 1888, McDonough Manufacturing was incorporated in Eau Claire. The company sold sawmill equipment all over the United States. As technological innovations allowed more lumber to be cut down each year, sawmill equipment improvements kept up and eventually surpassed the rate of logging that was taking place in the state.

Among the mechanical upgrades that increased sawmill production were the waterwheel, which was replaced by steam to power the sawmills, and the reciprocating saw, which was replaced by the circular saw in the 1850s, and in the late 1800s the circular saw was overtaken by the band saw. The amount of logs that were able to pass through the sawmill with the invention of the band saw outpaced the amount of logs being cut each year, and larger crews were needed to produce more logs. In the late 1800s, handmade shingles were replaced by machine-made shingles, which allowed mills to produce 50,000 shingles a day. In the late 1800s, almost every city and village in northern Wisconsin had at least one sawmill, and by 1894, Wisconsin was the leading producer of forest products.

Eventually, almost every part of the sawmill was mechanized, and the invention of the gas chain saw made both logging and lumber production more efficient.

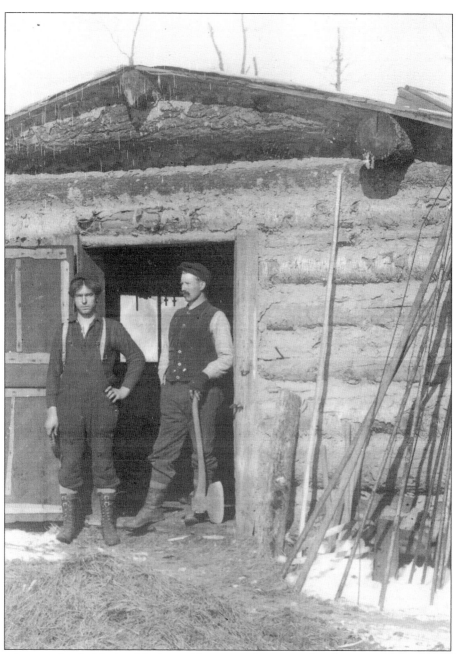

This photograph of a blacksmith shop with two smithies was taken between 1910 and 1920. In addition to horseshoes, the blacksmith repaired cant hooks, peaveys, and sleighs. A blacksmith in Oshkosh, A. Sanford, made the first peavey in Wisconsin, and he sold them for $5 to $6. A peavey consists of a handle 30–50 inches long with a metal spike at the end. The spike can be rammed into a log and a hook grabs the log at a second location. The handle allows the logger to roll or slide the log to a new position. A cant hook is similar to a peavey; it is a strong wooden pole with a curved, hooked iron bar. It was also called a "crow's foot." Both peaveys and cant hooks were used to roll and turn logs, dislodge logs when they were stuck in the woods or the river, and maneuver them in the sawmills to be cut.

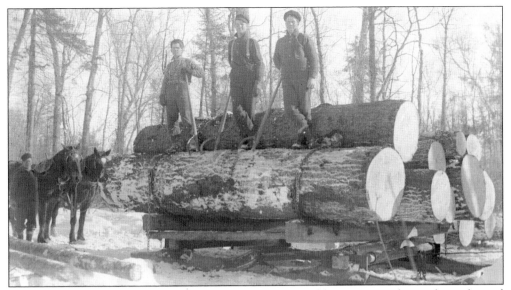

A trio of loggers with cant hooks in Barronette is pictured here. Notice the marks at the end of the logs. Logs were marked on both ends. The end marks were made with a heavy stamp hammer. Each lumber company registered its mark, and when the logs were sorted in the spring, the lumber companies were paid for any logs displaying their registered marks. (Paul Bunyan Logging Camp Museum.)

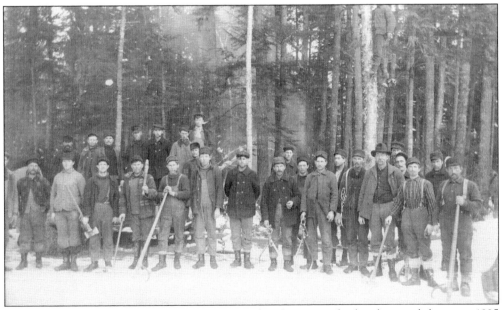

These men, possibly loggers from the Kaiser Lumber Company, display their tools between 1895 and 1905. The men present axes, skidding tongs, cant hooks, and measuring sticks—all items they used on a daily basis as they chopped down trees, cut them into logs, and hauled them to be stacked on a sled.

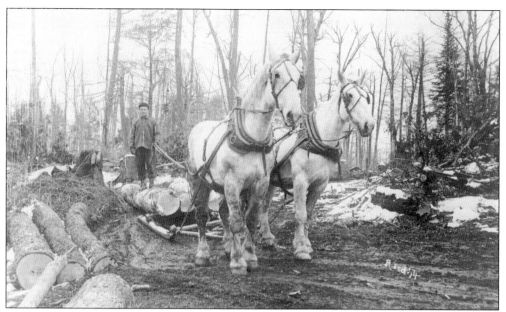

A man skids with a team of horses at Bemis Camp. The logs are piled on a "go-devil," a small sled to haul logs to another part of the forest. They were made from the crotch of a tree with an added crosspiece. A chain wrapped around the crosspiece and the log and back to the crosspiece.

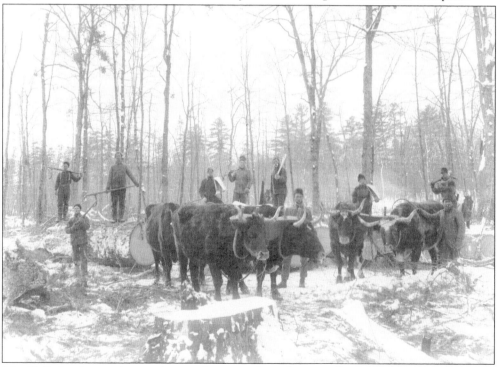

John C. Barland remembers working with oxen in the early years of logging. Around 1854, "Scotch and West, employed my little brother Tommie, a boy of 10 and myself, a boy of 13, to take our three yoke of oxen with two wagons, to take two loads of potatoes to the site of their prospective logging camp in the pine woods of the Wolf River. . . . It took seven days and nights."

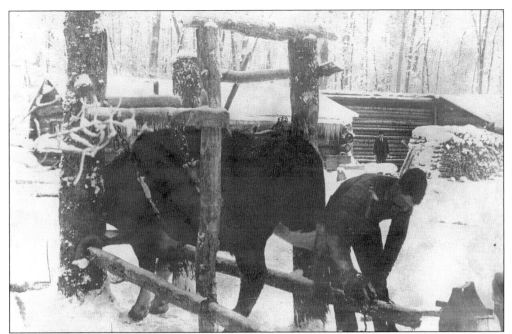

While oxen were generally easier to care for, with a gentler nature than horses, there was a major difference between the two in shoeing. Horses could stand on three feet while the fourth was shoed. Oxen cannot stand on three legs, so a special harness had to be built to hold them up as they were shoed.

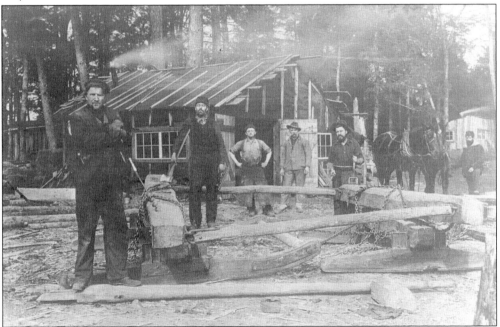

This is a view of a blacksmith shop with a crew, sled, and team of horses in front preparing to head to the woods. Sleds were often made at the camp from available wood and left unpainted. The four stout chains used on the bottom of the sled bound the outside logs of the lowest tier to the bunk to provide a firm bottom to the load and were called corner binds.

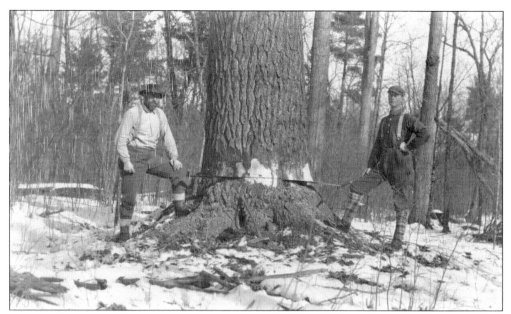

Two sawyers saw into a girdled tree. Many logging companies purchased their tools directly from Oshkosh Tools, which was established in 1887 to serve the Oshkosh area. After the logging industry moved west, the company diversified. Today, Oshkosh Tools are used in many industries and known for their durability and lasting value.

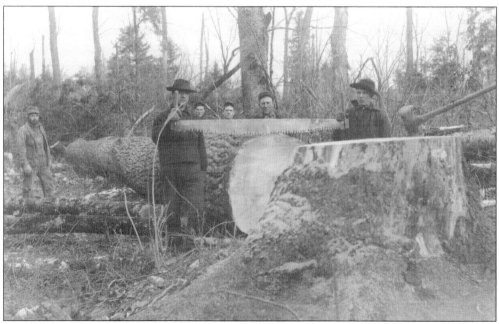

Sawyers used crosscut saws while choppers used axes. A pair of sawyers, or "buckers," was expected to cut an average of 100 logs a day. A "Swedish fiddle" was a slang term used for the crosscut saw because it made "music" in the woods as it was rhythmically worked back and forth through the team.

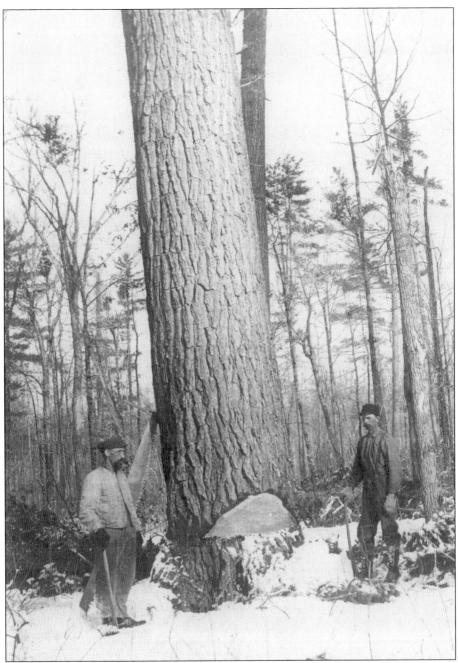

Sawyers stand next to a notched pine tree. The notch in the tree meant that it was intended to fall toward the open space at the front of the photograph. Even though choppers and sawyers tried to control how trees fell, accidents happened in the woods. In 1883, Richard Ryan had his leg crushed by a tree that fell on him. He carved storage boxes for Bibles from the log that fell on him. According to the Bureau of Labor Statistics (BLS), logging in the woods is still one of the most dangerous jobs there is. In a recent BLS report, the average American worker's work-related fatality rate is 3.2 in 100,000. The average logging employer's work-related fatality rate is 91 in 100,000, or 30 times greater than the average employee.

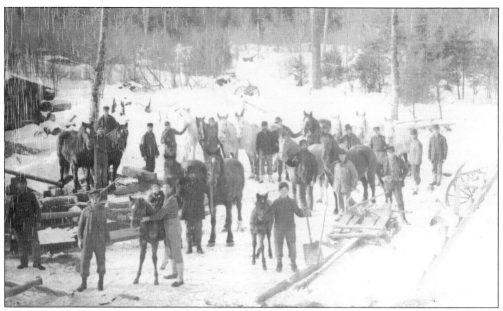

A group of loggers with horses is pictured here. Logging camps depended upon horses throughout the logging era. Given their critical nature, it was essential the horses received good treatment. Barn boys were in charge of feeding and grooming them throughout the day. A lack of care for the animals brought a sharp reprimand from the foreman. The young man in the right foreground is most likely a barn boy.

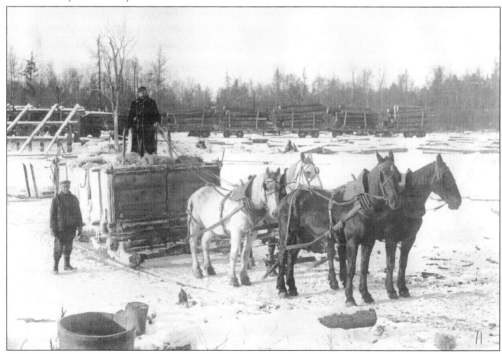

This is a photograph of a sprinkler about 1910. Plugs in the bottom of the water tank could be pulled, allowing water to sprinkle down the road. A bed of ice up to a foot thick was necessary to support the heavy sleighs. This process had to be performed every night.

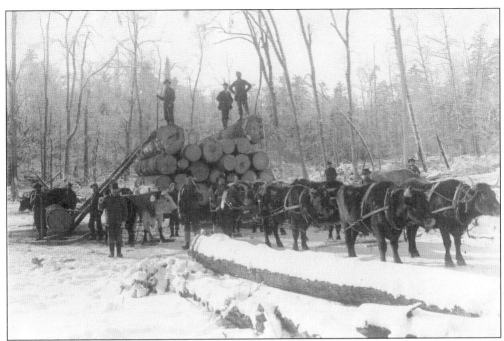

A crew decks logs onto a sled. Chain loading began about 1850. The chain connected to a sleigh and looped around the middle of the log. The horses were hooked up to the opposite end of the chain and pulled from the sleigh causing the log to roll up skid poles. Another chain bound the logs together. The cant hook kept the log from rolling off the ramp.

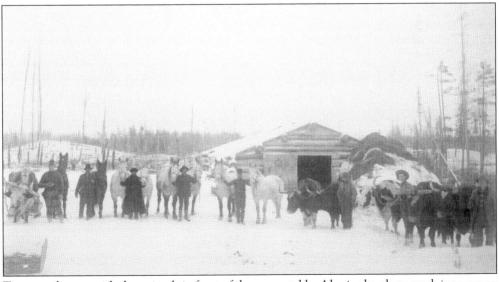

Teamsters line up with the animals in front of the camp stable. Also in the photograph is a manure pile mucked out from inside the stable. The number and mix of animals indicates that this is a small camp that existed in northern Wisconsin in the 1880s–1890s, the peak lumber years.

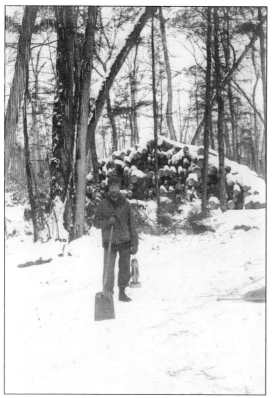

Pictured is a road monkey at McCann's Camp in Couderay in 1913. A tote road had to be cleared and graded to form a road so supplies and building materials could be brought in to build the logging camp. Logging roads also had to be cleared for a path to the river. Roads had to be wide enough to accommodate a sleigh or a sprinkler.

Teamsters move a jammer down a logging road in the early 1900s. Note the shovel in the background of the photograph. After heavy snows, road monkeys had to clear roads. Road monkeys were at the bottom of the payroll scale, making less than a dollar day. In some camps, road monkeys were called "blue jays" because they were always pecking at things in the camp roads.

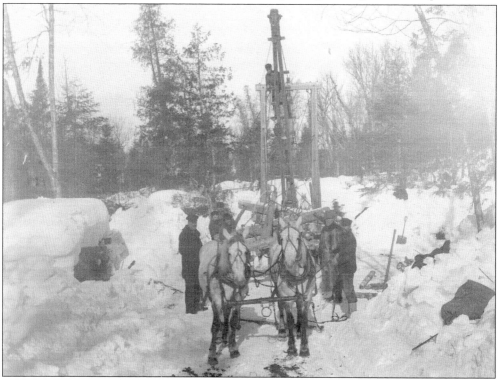

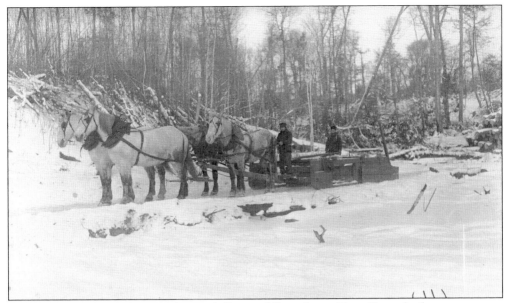

A rutter is seen on a logging road in 1910. Rutters followed sprinklers. Once the frozen water was sprinkled on the road, the rutter formed clean paths for the sleighs to follow the next day. The new tracks made it much easier for the horses to pull the sled.

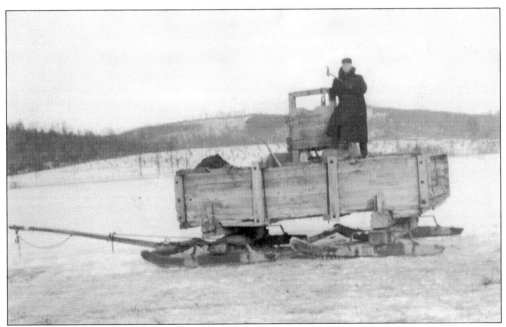

A road monkey poses in the rutter, which he will put to use after the men leave the woods for the day. In addition to icing roads and making new sled paths, road monkeys kept hay in the sleigh tracks for better movement, cleared debris from the road, and cleaned up horse manure from the paths.

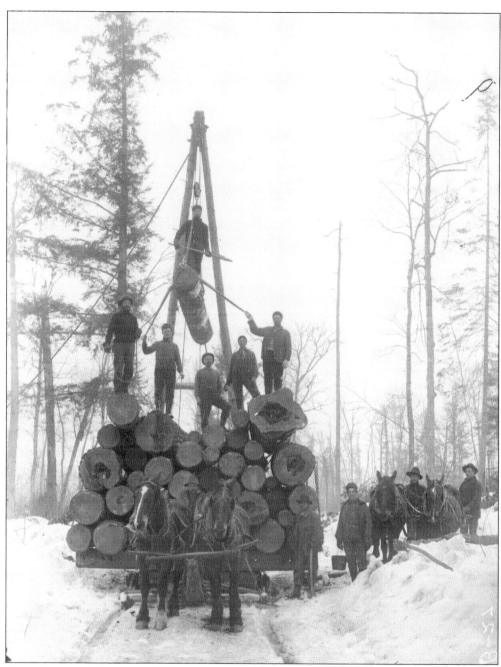

A crew loads a sled with an A-frame jammer. The jammer is built of two poles connected at the top. A third pole became a swing boom—a cable connected a team of horses to a stationary pulley. As the horses pulled the cable, a log was hoisted into the air. When the log reached the desired position, a man pulled a rope on the ground and the log was released onto the top of the pile. The swing boom had a great range. The jammer could even be used to load logs onto a railroad car. Running the jammer was a dangerous job. The same men who built the jammer also ran it during the winter. The construction of a jammer was simple. It was made almost entirely of logs to the specifications of the camp blacksmith. In the 1890s, steam-powered jammers were invented.

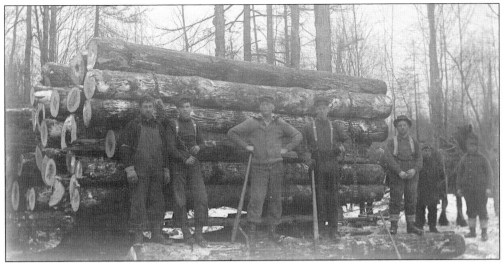

This is a photograph of a group of loggers in Barronette. These young men look content, but an article in the *Chippewa Herald* in 1882 provides another perspective: "And then after supper we roll into our soft, downy couch of lousy blankets, and lay and listen to . . . music by the entire band, and snoring in seven different languages, mostly imported--professional snorers from Germany and Norway . . . while the beautiful odor of wet socks and foot rags is heard in the near distance, and finally fall sleep to slow music, only to be awakened in a few minutes by the melodious voice of the cook, singing, 'roll out your dead bodies, daylight in the swamp.'" (Paul Bunyan Logging Camp Museum.)

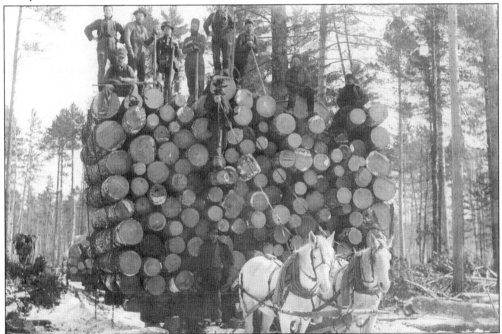

An extremely large load of 134 logs at the Lammer Brothers Camp in Drummond, Wisconsin, tells a "tall tale." Most of the photographs with large loads were Sunday pictures taken for fun by a photographer in the camp. Two horses could not have pulled a load of this weight. Hopefully, the logs stay put as the men on the top row hop off the pile.

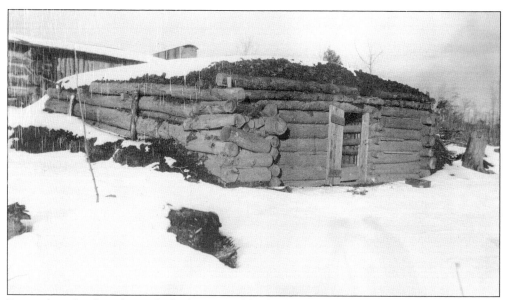

Pictured is a log "root house," which was used for food storage at lumber camp. The root house held dried fruits like prunes, peaches, and apricots. It also contained dried beans, peas, rice, and barley, and pounds of flour. Molasses and salt pork were kept in barrels in the root house.

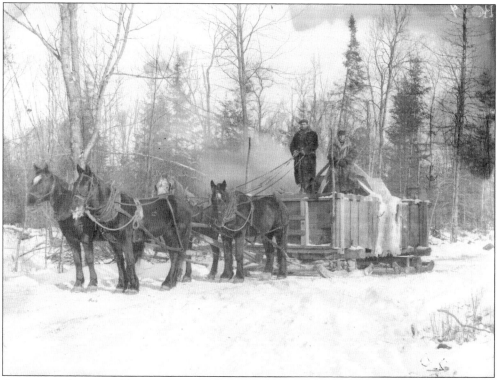

An icing tank crew and horse team are on the road. Usually, dynamite was used to blast a hole in a lake for water to be obtained. To keep the inside of the sprinkler from freezing, a gallon jug filled with kerosene and a wick at the mouth was lit and set on the bottom of the tank to prevent crusting.

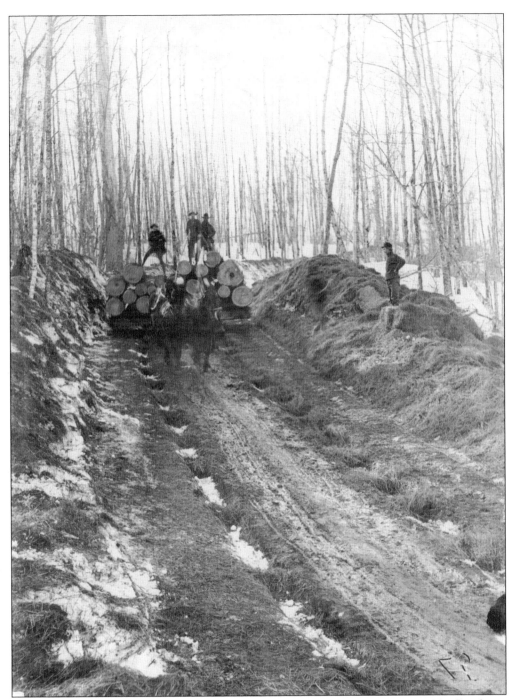

A sleigh is pulled down a grade at Ole Emerson's Camp in Cable, Wisconsin, in 1904. Roadways had to be able to accommodate heavy sleighs. The uphill gradient could not be too steep, or even a four-horse team could not pull the heavy load. It could not be too sharp on the downhill side either, because it could cause a sleigh to overrun the team of horses.

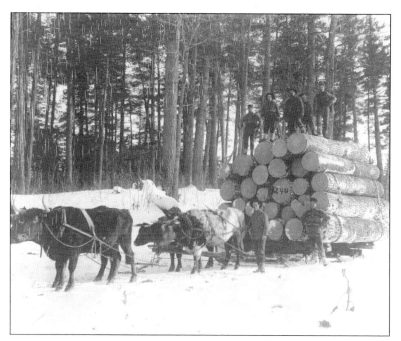

A crew stands on a load of logs pulled by a team of oxen in 1900. Louie Blanchard worked in the woods from 1886 to 1912. In a memoir, he writes, "When I was driving oxen on the tote road, hauling logs, I'd leave them right where we was when the cook blowed his horn hay kept the oxen going while we went to the cook's outdoor dinner in the swamp."

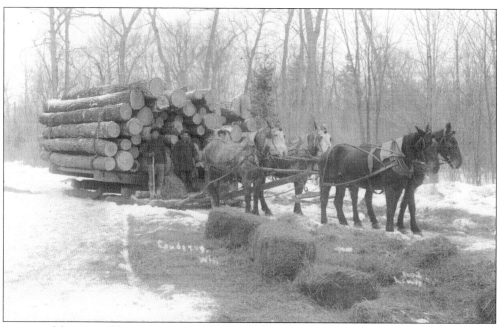

A team of drivers and horses is pictured with a sled between 1900 and 1910. When it was noon, everybody stopped work, even the horses. The horses had a hay break, the men a hot meal from camp. Louie Blanchard recalls, "We never wasted much time moving through the snow over to the roaring fire and the smell of baked beans and beef and bread and things like that."

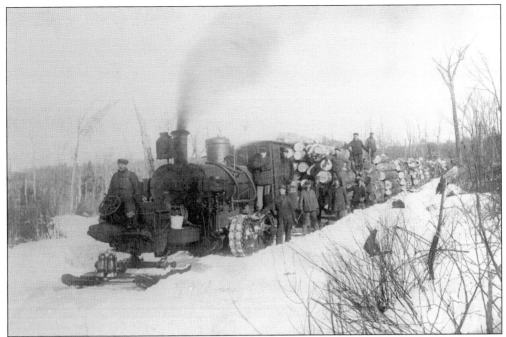

This is a photograph of a Phoenix Log Hauler at Jones Lumber Company in Wabeno, Wisconsin. The Phoenix could pull the load of 10 teams of horses. This steam hauler is pulling 79,000 board feet of mixed lumber. The engineer is James A. Peterson of New Auburn. (Paul Bunyan Logging Camp Museum.)

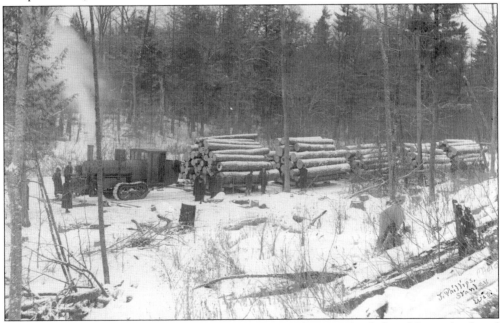

A Phoenix log hauler crew is shown here. About 1900, Alvin Lombard, from Maine, developed the first steam log hauler. In 1903, he sold his patent to Phoenix Manufacturing in Eau Claire. The Phoenix company improved the design, enabling the new version to pull twice the load as the Lombard.

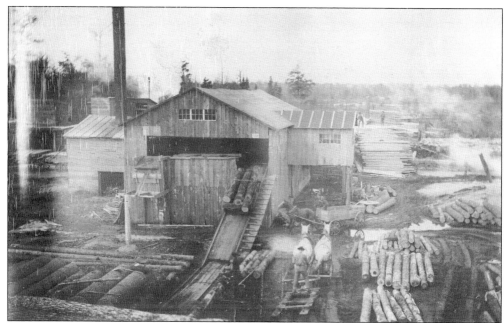

The Hirt Brothers Mill in Deerbrook was situated on the Eau Claire River in 1908. After the logs were sent downstream, they were corralled into a holding pond near the mill. The logs were put on the ramp and taken into the sawmill to be cut. (Langlade County Historical Society; photograph by Arthur Kingsbury.)

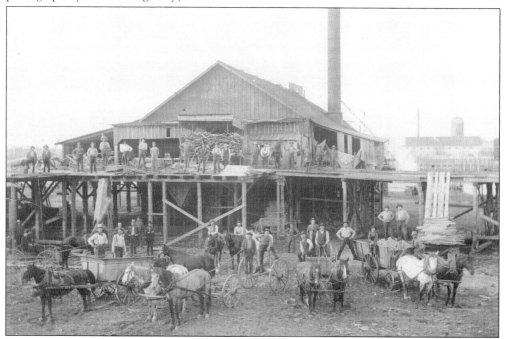

The Daniel Shaw Shingle Mill in Eau Claire is pictured here. The Shaws worked hard to increase the size and efficiency of their mill. To increase the annual cut, worn-out and outmoded equipment was replaced. In 1882, a modern shingle mill was installed to supplement the hand machine, which enabled the mill to produce 100,000 shingles per day.

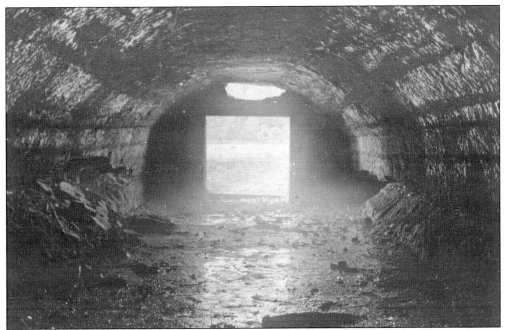

This is the exit of the flume into Half Moon Lake in Eau Claire. In 1879, Eau Claire had become a larger city, and floating logs down the river created too much congestion, so local mill owners devised a flume-canal-tunnel to bring the logs 1.2 miles from Dells Pond to Half Moon Lake. The 8-by-10-foot wooden flume ran along the rock wall of the river's west bank.

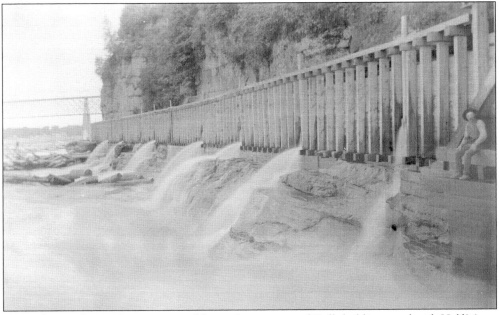

Shown here is the northern section of flume that connected Dells holding pond with Half Moon Lake and sawmills at the foot of the lake. The planked catwalk that allowed workers to monitor the flume for jams can be seen. The flume turned inland and fed five feet of water into a canal parallel to the river. At the end of the canal, logs dropped 18 feet into a 1,000-foot-long tunnel going to Half Moon Lake.

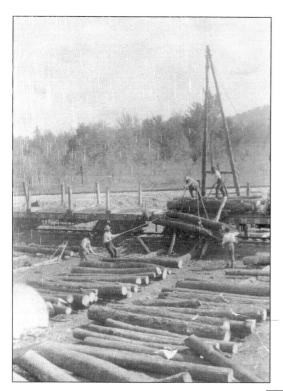

Using an A-frame jammer, a crew decks logs at a landing near Camp Weston, part of the W.J. Starr Lumber Company. The A-frame was often referred to as a "wood" jammer or a "side" jammer. Even when it was no longer used in the woods, the jammer was often put to use loading flat railroad cars with logs.

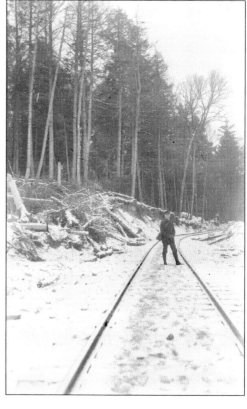

A logging camp employee stands on railroad tracks recently cut into the woods in Draper, Sawyer County, in 1913. Railroads made life both easier and harder for the lumber industry. The first lumber cars were "Russells." They did not have a real deck, just long bunks to set a row of logs. A major concern for loggers was fire created by sparks as the train traveled through the area.

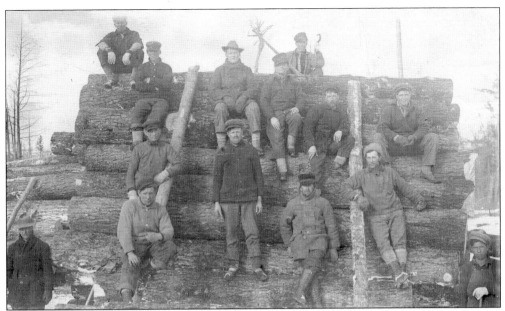

A group of woodsmen poses on logs between 1891 and 1905 in Rusk County. For years, logs were loaded by a cross-haul method of rolling and chaining the logs to "stake free sleighs." The chain hook held by the man at the top of the log pile is the clue that indicates that they are using a power source to help roll the logs up the ramp.

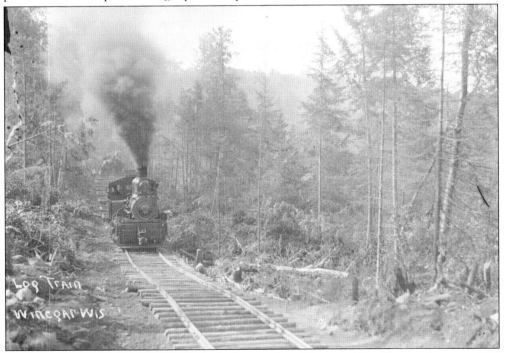

A steam engine pulls cars of logs through the woods in Winegar, Vilas County, between 1910 and 1920. Railroad tracks had to be checked daily for broken ties, split or loose rails, pulled spikes, and items lying on the tracks. (Langlade County Historical Society; photograph by Arthur Kingsbury.)

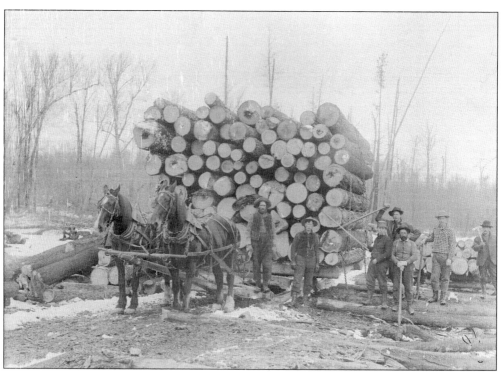

A Dells Lumber Company crew with a horse-drawn sled with a large load of logs is pictured near Kennedy. The horses' names are Nell and Jane, and the man next to the horse is Emil Kuhnert. The photograph was taken between 1908 and 1910.

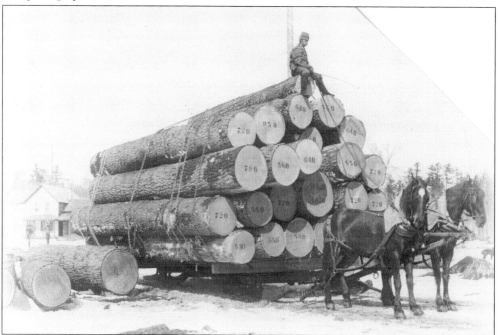

This load of logs shows the number of feet scaled in the Eau Pleine River Basin in Marathon County. (McMillan Memorial Library, Wisconsin Rapids.)

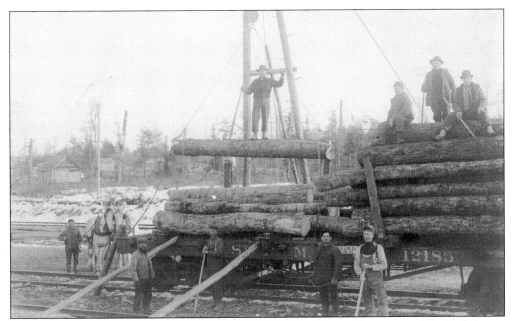

A crew decks logs onto railroad cars in Winter in Sawyer County. Logs were often loaded onto "state-pocket" flatcars, which needed only one chain to secure the load, and the logs were unloaded by tripping pockets to roll off the logs. Loggers could also be transported by train to the woods, allowing forests farther away from camp to be cleared.

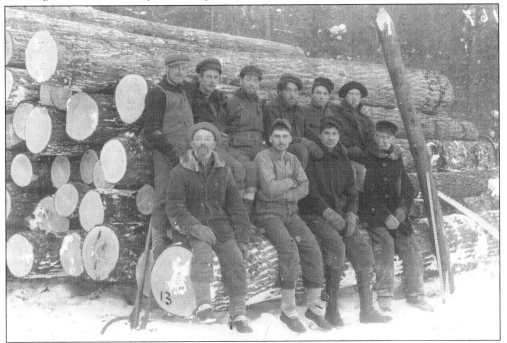

A group of loggers sits on stacked logs in 1913. Logs were hauled to the edge of rivers and stacked there to await the spring run. Most of the men in the photograph are probably in their 20s and 30s, with the exception of the fellow on the bottom right. Logging was a young man's game because it required such physical endurance in a pretty inhospitable climate.

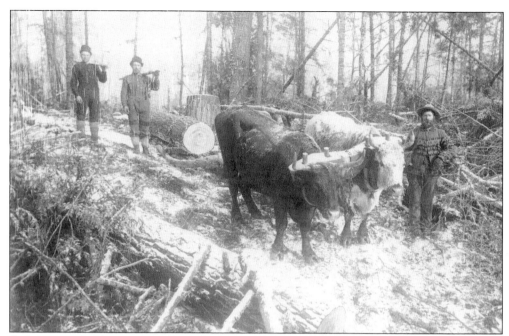

A three-man skidding crew works with a team of oxen. What is subtlety shown in the photograph is the logging road that had to be prepared before the oxen could even get into the woods. Notice the felled trees to the right and left. Logging roads as much as anything else helped to reshape the landscape of northern Wisconsin.

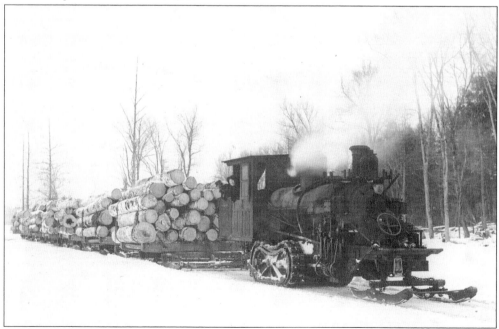

The Phoenix at the Rice Lake Lumber Company hauls logs at the Overland Spur in 1914. The driver is easy to lose in this photograph, sitting as he is at the very front of the engine. Unlike train engineers, log hauler engineers had to sit facing the weather head-on and did not have the protection of a cab.

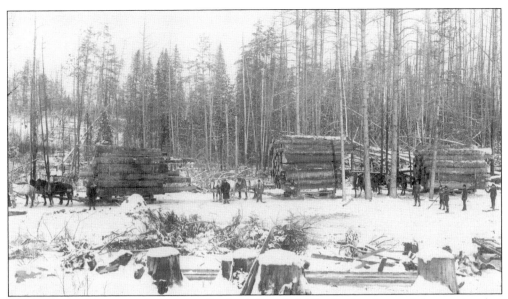

Three teams of horses and drivers pull a log-laden sled. The log haulers and then trains that replaced horses as the primary source of power did not need boarding, feeding, or health care. They did need mechanics and coal and were generally more expensive to fix and maintain than horses. The money saved by moving logs at a greater distance in a shorter amount of time was worth the extra maintenance expense, however.

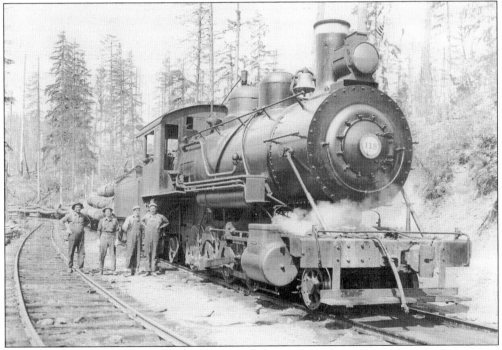

Trains replaced log haulers as the primary means for moving logs out of the woods, but they required a crew with different sets of skills. Train engineers needed to be able to understand the physics of their load and operate a steam engine. They were also multipurpose, and some trains that hauled logs also provided limited passenger service.

A logging camp employee uses the Gabreel horn to call the men in to lunch. The Gabreel, or sometimes Gabriel horn, was a long, tin horn the cookee used to let the men know lunch was ready when they were working close to the cook shanty.

Even Iverson was given this cant hook to help load logs. He worked for the railroad in Jackson County. Canting hooks were three- or four-foot-long wooden poles with a swinging hook at the end. The first patent submitted for a cant hook was 1856.

Five

A TRIP DOWN THE RIVER

Employing the rivers for transportation was a necessity for early logging. While the rivers were efficient, a lot of work was needed to get the waterways ready for the excessive loads every spring. Before the spring thaw, crews had to clean up the river, clearing out stumps, trees, rocks, and sandbars. A path along the riverbank also had to be cleared, so men could walk along the river drive to keep an eye on the loads.

River driving was the most dangerous job in the logging industry, and many men drowned during the 70 years of logging in Wisconsin. Logs could completely cover a river for 25 miles. The rear crew pushed stranded logs back into the flow. With spiked shoes, they rode logs, waded in icy cold water, or steered bateaux, boats similar to canoes, to keep the logs moving to prevent logjams.

The most tragic logjam in Wisconsin happened July 7, 1905, when 11 men drowned in the Chippewa River near what is now Holcombe. Sixteen men in a bateau tried to break up a logjam. Five men leaped to safety, and the rest of the crew was sucked into the current, the boat overturned, and the men were thrown against the logs and rocks. A search party was sent from Chippewa Falls, and all but a few of the men's bodies were recovered. Louis Cokey, one of the men who died that day, was the fifth member of his family to drown.

One of the largest jams occurred in the 1880s when Henry Sherry's crew from Neenah was driving down the Wolf River. The logs jammed at the foot of Tea Kettle Rapids and held back the water forcing the logs over the top of the jam, creating a 60-foot pileup. It took two weeks to break up the logjam because it was in the days before dynamite was routinely used.

The last river drive in Wisconsin was on the Flambeau River in 1925.

This is a photograph of Paint Creek in Chippewa County in 1915 before the dam was created. Dams often had to be built to overcome rapids. Dams were also necessary to regulate the flow of logs and the level of the water in the river. Some of these dams were taken over by the power companies for use in producing hydroelectric power.

Loggers steer their bateau through the rapids of the Wolf River. Rafting on the rivers was legal due to the Northwest Ordinance of 1787, which declared that waters leading to the Mississippi or the St. Lawrence were common highways, free of taxes. Wisconsin adopted the ordinance in 1849. (Langlade County Historical Society; photograph by Arthur Kingsbury.)

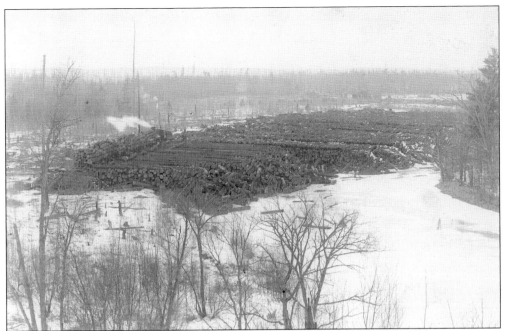

Logs are stacked atop ice-covered rivers waiting for the spring thaw at the Big Bend Landing on the Chippewa River in Rusk County in 1883. Along with the river drivers, a crew of men traveled on paths next to the river to watch for areas that could catch logs and cause jams.

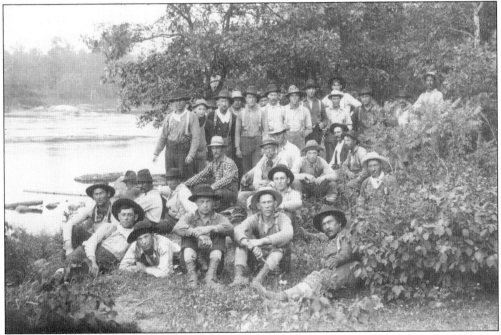

A log-driving crew for the Chippewa Lumber and Boom Company is shown here in 1903. The river crew was made up of three teams: a land crew kept a constant supply of logs moving into the river, one crew went ahead of the logs to clear obstacles out of the way, and one crew drove behind the logs to make sure they did not catch on a root or a rock.

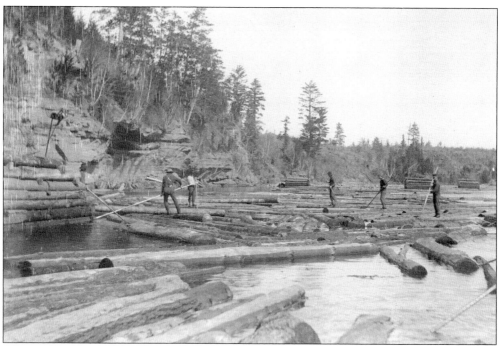

A crew of five men, using peavey hooks and pike poles, sorts logs on the Chippewa River between 1890 and 1900. To keep logs moving in an orderly direction, men could ride in bateaux, ride a log, or wade in the icy water. Men on the river crew were called "river pigs."

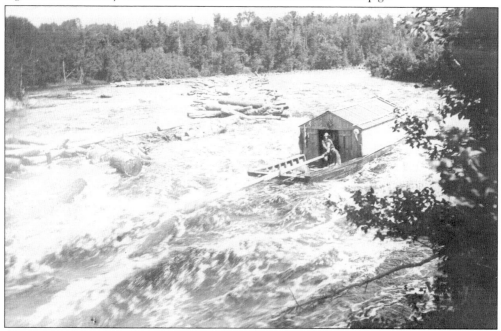

A wanigan comes through the rapids between 1890 and 1900. The boat traveled with the river drivers, carrying supplies and a cook who provided meals. While the men were driving, the cook could restock food staples at villages along the river. The cook also prepared lunches put into canvas sacks for the drivers to carry with them.

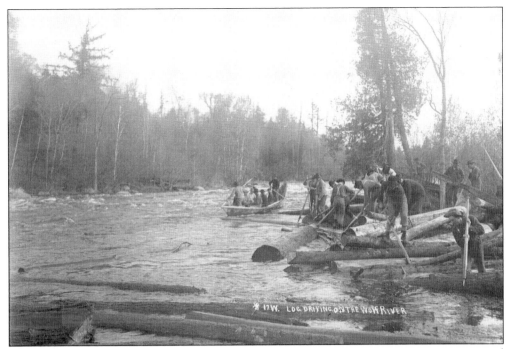

A crew drives on the Wolf River in the early 1900s. The largest logjam in Wisconsin occurred in the 1880s when a Neenah crew encountered a jam at the foot of Tea Kettle Rapids. Logs were forced over the top of the jam, creating a 60-foot-high pile. It took two weeks to break it up because dynamite was not being routinely used at this time. (Langlade County Historical Society; photograph by Arthur Kingsbury.)

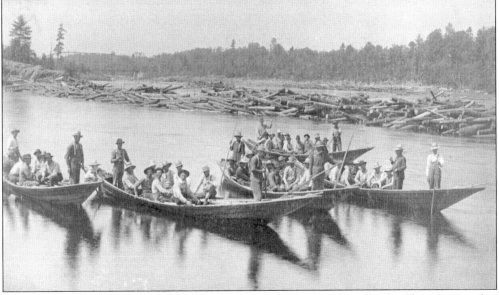

This photograph documents the last river drive on the Chippewa River by the Chippewa Lumber and Boom Company in 1909. To help combat the effects of the icy water and dry skin, river drivers often coated their lower body with lard. While the men received $1 per day in the camps, men chosen for the river drive received $2 per day because the job was so dangerous.

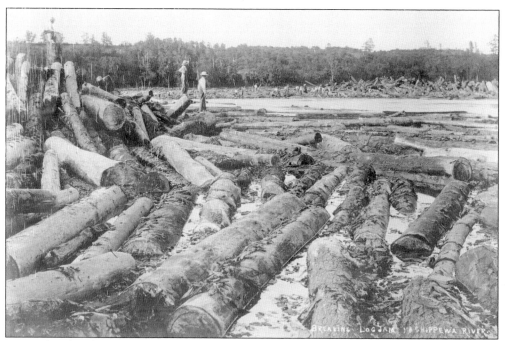

A crew breaks a logjam at the "Big Eddy" on the Chippewa River in 1903. Logs could cover a river for 25 miles, and a logjam could create a pile more than 50 feet high in minutes. If the water began to overflow onto the banks, it often took logs with it.

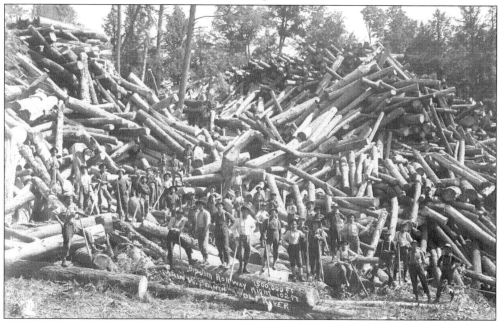

Henry Sherry's crew from the Neenah area at the Big Jim Rollaway poses near the main west branch of the Wolf River. This pile is 102 feet high and made up of 1.5 million board feet. Henry Sherry was one of the most famous Wisconsin lumber barons. He was very generous and influenced much of Neenah's residential and commercial development. (Langlade County Historical Society; photograph by Arthur Kingsbury.)

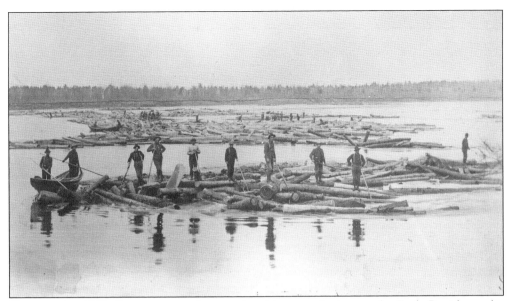

Photographer D.H. Brown captured a crew breaking up a logjam at the Eagle Rapids on the Chippewa River in 1909. Rapids were probably the greatest cause of logjams during the spring drive. Low water also caused a lot of problems, as logs could easily catch on sandbars or rocks.

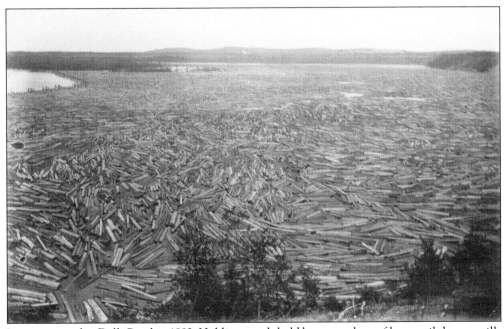

Logs are stored at Dells Pond in 1892. Holding ponds held huge numbers of logs until the sawmills were ready for them. Sawmills often were built near ponds for this purpose. The water was also helpful if a fire occurred, which was a daily concern in a society that built with wood.

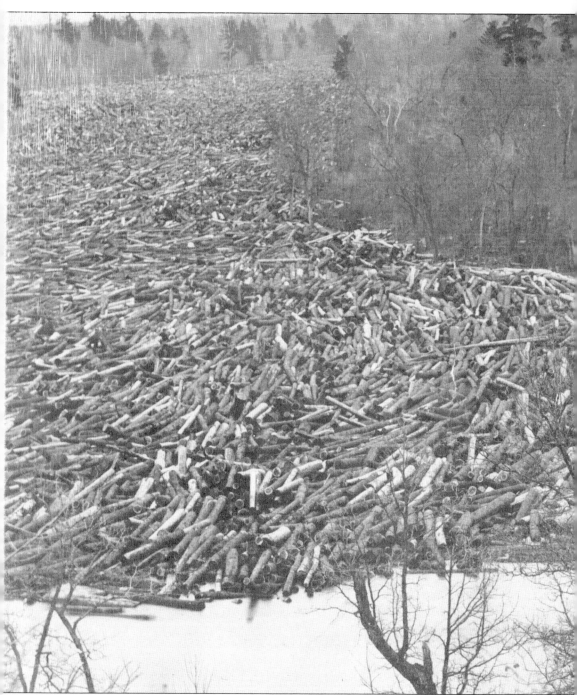

A logjam is pictured at the Chippewa Lumber and Boom Company at Paint Creek in 1869. The *Eau Claire Free Press* described the jams as "20 to 50 tiers in depth, and forming a complete gorge of [200 yards] in width, rendering invisible the water of the river for a distance of two miles." *Harper's Weekly* commissioned Eau Claire photographer Nathan A. Preston to capture this image. The magazine then published a wood engraving of the photograph, and people from around the United States read about the logjam in Wisconsin. The most tragic logjam occurred on the

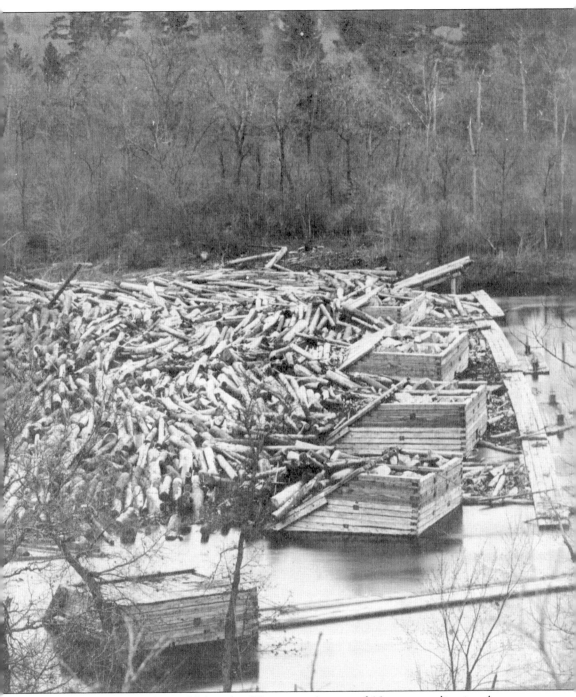

Chippewa River in 1905 near Holcombe, Wisconsin. A team of 16 men traveling in a bateau from Chippewa Falls was sent to break up the jam. When they arrived at the area, the bateau was sucked into the current. Five men leaped to safety before the boat overturned, and the rest of the men were thrown against the rocks and logs. Louis Cokey, one of the men who died, was the fifth member of his family to drown.

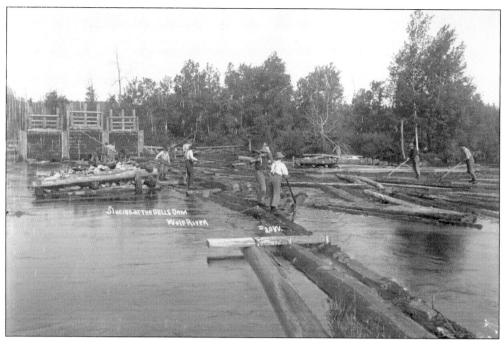

A team sluices at the Dells Dam on the Wolf River. The sluice was an artificial channel for conducting water, often fitted with a gate at the upper end for regulating the flow. (Langlade County Historical Society; photograph by Arthur Kingsbury.)

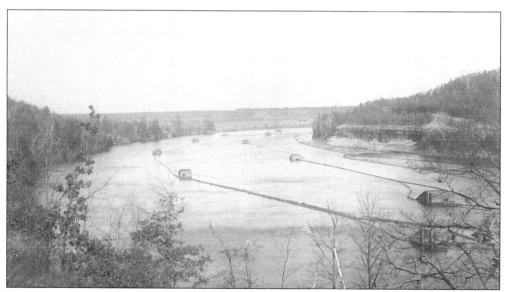

This photograph displays a large boom on the Chippewa River near Dells Dam about 1900. A logging boom was a barrier of floating logs stretched across the river to catch logs for sorting. The logs were sorted by their stamp marks. Marks were stamped onto the end of the logs. Each company had its stamp, which is how sawmills knew whom to pay for the logs.

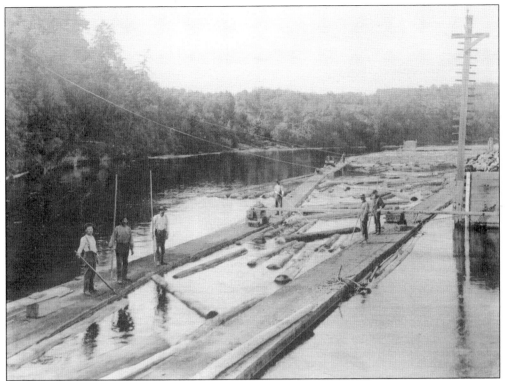

A crew sorts logs on Dells Pond between 1890 and 1910. A drive would run into a series of gates, and as the logs came down the river, drivers used pike poles to direct them into the gates according to their log marks. Some gates carried logs directly to the sawmill, while logs going farther downriver were run through a main gate.

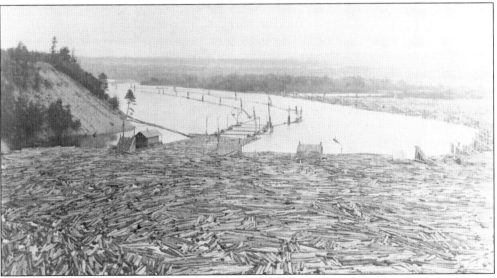

Logs arriving at holding ponds was a common sight every spring in Wisconsin. Fred Burke, an Oconto historian, estimated that from 1867 to 1917, about 10.6 billion board feet of lumber floated down the Brule-Menominee River. The peak year of 1889 included 4,245,763 logs, or 642,137,318 board feet.

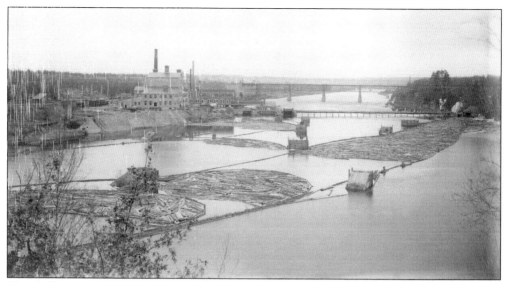

This holding pond was situated on the north side of Eau Claire. Once the logging industry moved west and the sawmills closed, many holding ponds were turned into recreational spots for swimming, fishing, or ice-skating.

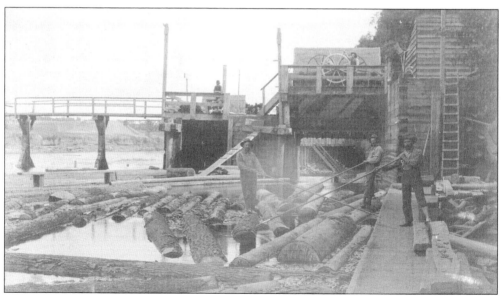

A crew of men sorts logs at a sawmill. Many sawmills were small-time operations, and the majority of them failed. At its peak, Eau Claire, with more sawmills than anywhere else in the world, had 16. The establishment of a sawmill often attracted other businesses, and cities grew up around the area.

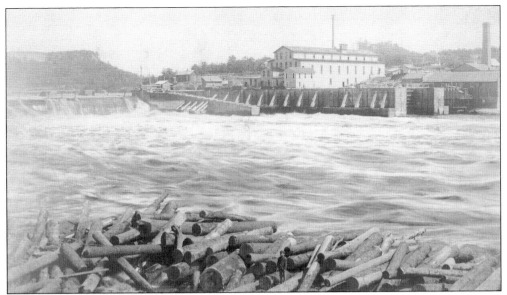

A mill located near a dam for a holding pond was a typical sight in the late 1800s. In 1890, an article in the *Eau Claire Leader Telegram* noted that the secret to Eau Claire's success has "been its storage capacity for logs, thus building up an extensive saw mill industry. The Dells reservoir, formed by damming the Chippewa river, is capable of holding 300,000,000 feet of logs. Then there is, near the center of the city, Half Moon lake, with a capacity of 100,000,000."

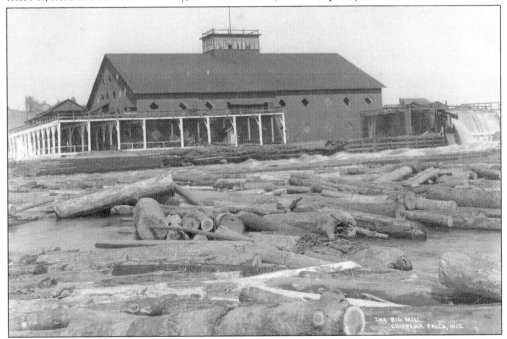

This view of the Chippewa Lumber and Boom Company sawmill in Chippewa Falls is from about 1900. The Chippewa Lumber and Boom Company was the largest indoor sawmill in the world. In 1890, it produced 51.5 million board feet. The plant occupied 10 acres with stacking yards, sheds, and the main mill. About 400 people were employed year-round—at the mill in the spring, summer, and fall and in the woods in the winter.

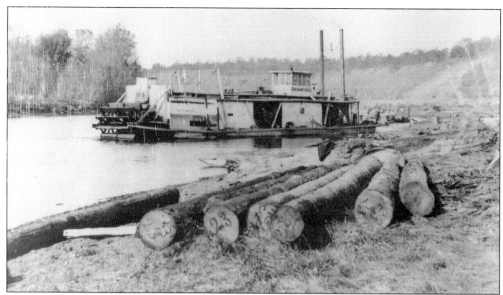

The *Ida Campbell* steamboat, owned by Capt. James Campbell and named after his daughter, traveled on the Wabasha and Chippewa Rivers. River pigs—loggers who drove the logs down the river—had to make their way back home after the drive. Some walked, and others rode a steamboat like the *Ida Campbell*. (Murphy Library, University of La Crosse.)

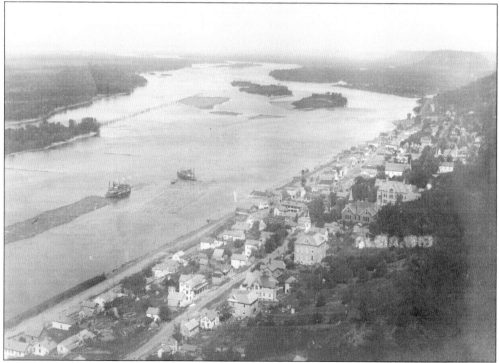

This view of Alma, Wisconsin, from about 1908, shows log rafts moving down the Mississippi River, which was quite a common practice until 1915. Note the straight row of pilings and booms in the river in upper left corner, which was used to float logs into a slough on the Minnesota side to avoid paying a Wisconsin tax of 10¢ a log. (Murphy Library, University of La Crosse.)

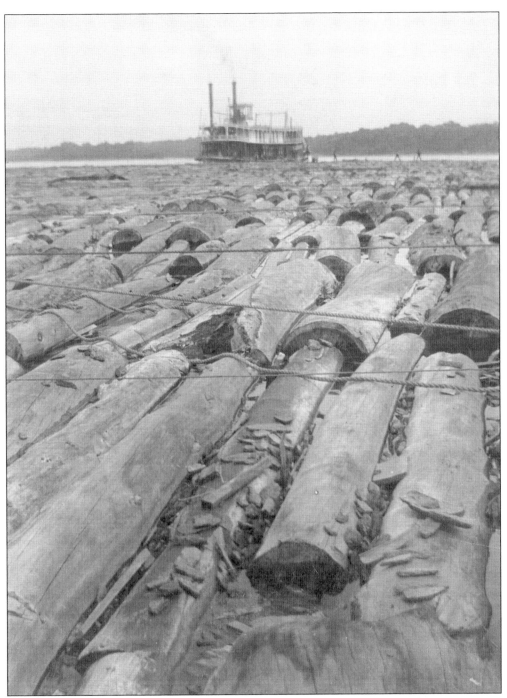

The steam wheel towboat *Ellen* moves a log raft on the Mississippi River in 1910. Mississippi operators, known as "downriver" men, were opposed by lumber companies in northern Wisconsin for taking lumber out of the state. The upper-river companies stopped the drive of downriver logs, causing delays. A huge flood in 1880 diverted upper-river logs into the Mississippi. Upper-river companies finally agreed to exchange downriver logs they were holding for the diverted logs. (Murphy Library, University of La Crosse.)

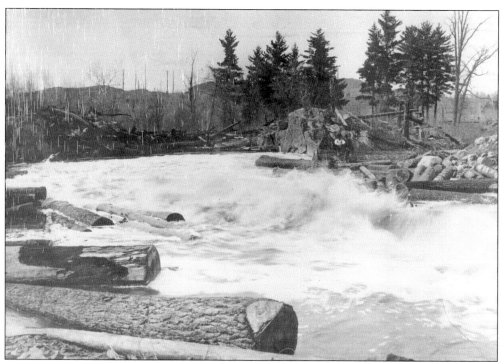

Piles of logs try to navigate the swift running water. Moving logs through the rapids was the most dangerous part of the river drive. About 10 percent of the season's cut was lost during river drives. If rivers were low, logs could be stranded upstream far from the sawmills and the entire winter's cut could be lost.

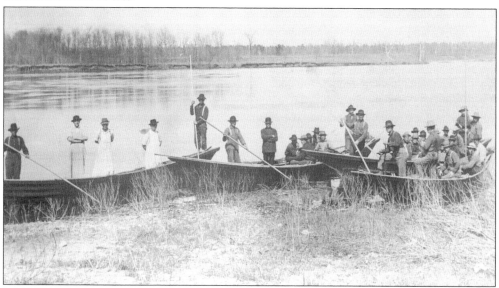

In 1909, the last Chippewa Lumber and Boom Company log drive halted while the men were photographed during the historic event. The man in the white hat (his back to the photographer) is Archie Smith, the drive boss. River drives transformed many Wisconsin rivers. In 1878, a large dam near Holcombe could raise the Chippewa River three feet 100 miles downstream when fully open; at least 148 dams were built on the Chippewa and its tributaries.

Six

THE CUTOVER AND CONSERVATION EFFORTS

Visitors in Wisconsin in the early 1900s would be surprised to learn that today more than 2.2 million acres of forests exist. After the logging crews decimated the forests, many woods sat empty for years without any attempt to replant.

Much of the stump-filled land was sold to immigrants from Europe as farmland. When these new landowners arrived at their new farms, they found brush, limbs, and treetops scattered over the ground, as well as millions of stumps. With the loss of the trees, runoff increased, lowering stream levels and creating possible flood conditions. With marshes drying up and streams full of silt, the fish habitat decreased. Less tree cover resulted in the elimination of many game animals. These conditions made a Herculean process out of what was already hard work for farmers preparing cropland.

In 1915, the State Park Board merged with the State Board of Forestry, the Fisheries Commission, and the State Game Warden Department to form a new agency: the State Conservation Commission. These types of groups started the conservation conversation.

In 1933, Pres. Franklin D. Roosevelt began the Civilian Conservation Corps (CCC). The CCC funded men to plant trees, implement water conservation procedures, control erosion, build dams, establish fire lane cuts, and clean slashing in cutover land. These practices were phased out when World War II demanded a huge number of soldiers.

After World War II, private industry, concerned about pulp shortages, helped fund Trees for Tomorrow, which distributed or planted 23 million trees and prepared management plans for 370,000 acres of private woodlands. The tree-planting program was terminated in the early 1970s, replaced by an emphasis on environmental studies and conservation education.

Since that time, conservation efforts in Wisconsin have been an important part of the state legacy. Many conservation procedures have been implemented.

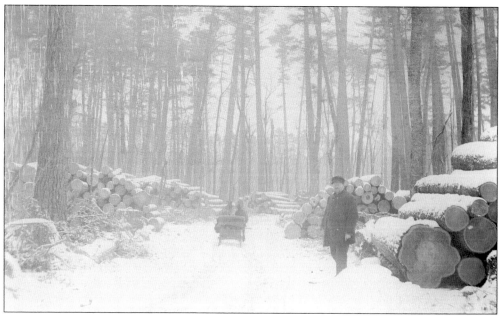

This photograph shows a stand of white pines and a skidway at Birch Creek. Vast cutting changed the landscape of northern Wisconsin. In 1898, forester Filbert Roth estimated that in the 27 northern counties, only 13 percent of the original pine was still standing. (Dunn County Historical Society.)

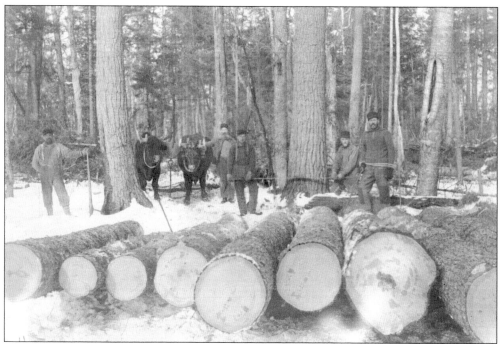

After the devastation left behind by the lumber industry, runoff increased and streams levels were lowered or dried up altogether. Now that sunlight could get through the no-longer-thick canopies, fish habitats changed. Both moose and caribou were entirely gone from the state.

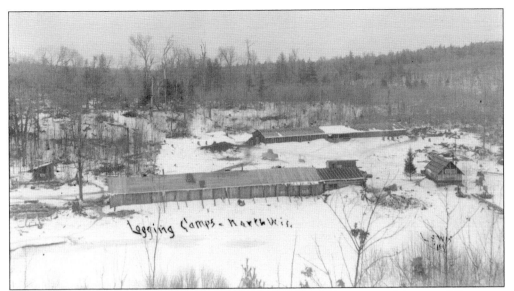

Abandoned logging camps were scattered throughout the northern part of the state. The towns and cities that had grown up with the lumber industry now needed to attract new settlers and businesses to keep their economies alive. Many of these communities targeted farmers to purchase the now-vacant acres.

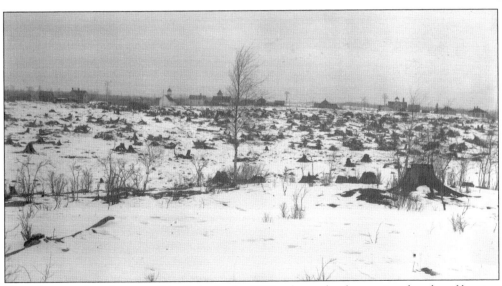

This photograph, taken near Rice Lake in the 1800s, shows the destruction decades of logging had caused to the forests. Trying to cultivate land full of brush and stumps was a Herculean task for farmers. Many salesmen exaggerated the benefits of owning cutover land. The University of Wisconsin's College of Agriculture also encouraged settlement by overstating the land's potential. (Joe Sirianni.)

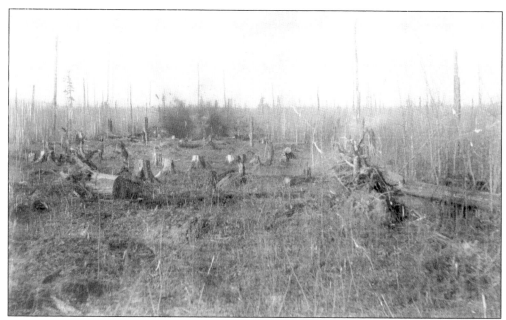

Land is being cleared to establish Main Street for what would become Holcombe in Chippewa County. The city of Holcombe was created in 1902 when a post office was built. The city was named for one of the railroad officials' acquaintances. Despite being located in the cutover area, it is now a recreational paradise.

William Buresh plays accordion for the wedding of John and Annie Sedivy, children of Bohemian immigrants. Eastern Europeans, many whose first homes in the United States were in industrial cities, moved to the cutover lands to farm, forming ethnic pockets in the region.

DO YOU WANT TO BUY A FARM?

WRITE

Cypreansen Brothers

FARM LANDS

⚜

EAU CLAIRE, WIS.

ALFRED CYPREANSEN, REGISTER U. S. LAND OFFICE. 🌿 🌿 🌿 🌿 🌿 🌿 🌿 🌿 SIGVART CYPREANSEN.

THE THOS. D. MURPHY CO., RED OAK, IA.

Sigvart and Alfred Cypreansen conducted their land sales business in downtown Eau Claire. They hired agent Vincent Beneesh to advertise their land in newspapers published in the languages spoken by people from Bohemia. By 1905, about 100 Bohemian families had settled around Drywood near Cadott. Immigrants from Bohemia, who spoke mostly Czech, were numbered among the seven million Germans who migrated to the United States between 1850 and 1900, usually for economic reasons.

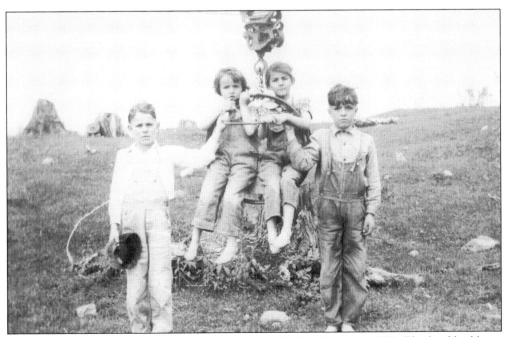

Cousins play on tire rim swing on a farm located in Taylor County in 1938. The land had been woods only a few years earlier, as seen by the massive stumps. The cousins from left to right are Robert Cooper, Inez Cooper, Irene Cooper, and Herbert Cooper.

An unidentified man stands among the remains of dynamited stumps between 1910 and 1920. Unlike hardwood trees, pine stumps did not disintegrate naturally. Dean Harry Russell of the College of Agriculture in Madison secured surplus military dynamite and provided it to owners along with demonstrations about how to use it.

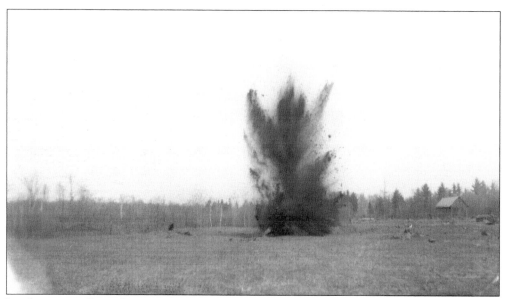

Landowners in Price County, Wisconsin, bought 138,000 pounds of dynamite. Dynamite cost $12.20 per acre and an additional $5 per acre for labor. Even those farmers who could afford to purchase the dynamite could not clear more than a few acres a year. In 1912, DuPont published a handbook explaining how dynamite aided agriculture.

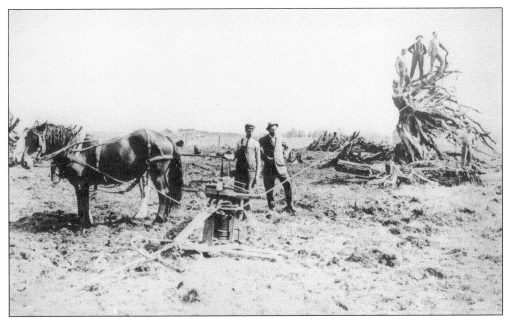

Shown here is a demonstration of a stump puller at Westboro in Taylor County. Some farmers used mechanical stump pullers. A team of horses turned a large screw or wheel on a tripod, and it meshed with a block so that when it was raised or turned, the stump it was chained to would pull up.

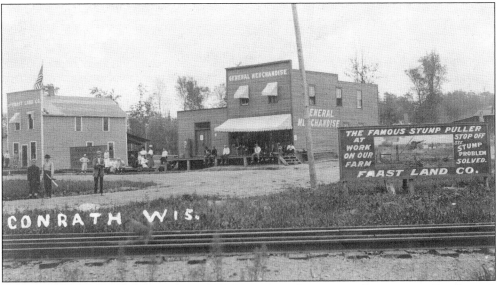

A postcard from Conrath, Wisconsin, in 1911 features an advertisement for a stump puller. Conrath was named for Frank and Charles Conrath, loggers who settled in the area. Mechanical stump pullers became more popular when the cost of dynamite rose significantly after 1910. Cultivating crops among stumps was an expensive task. A stump, along with its roots, caused a great deal of lost time, resulted in broken equipment, and harbored troublesome insects.

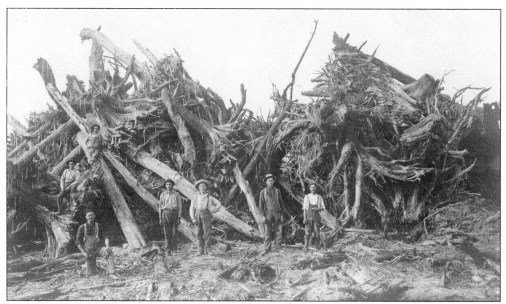

According to the *Annual Report of the Agricultural Experiment Station for the University of Wisconsin,* "movable pilers of various types are in use. Of these the Conrath piler has probably met with the most approval. Blue prints of this homemade machine can be secured from the College of Agriculture. The iron parts can be purchased from stump puller manufacturers or made by blacksmiths for about $60."

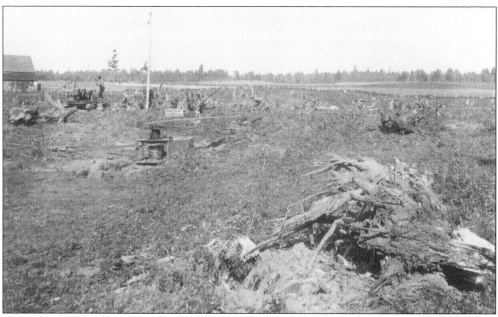

This photograph shows the laborious process of pulling stumps. It is not too surprising that in the cutover land, dairying started to become more popular. Successful dairy farms in the cutover lands had three factors in common: they had at least 10 cows, a nearby market to buy their milk, and at least an acre of hay per cow.

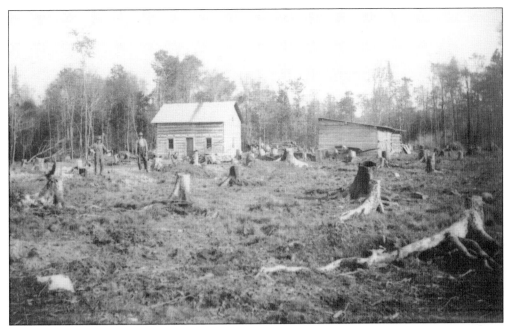

Several farmers oversee the stumps strewn all over their farmland in Medford in Taylor County. Many farmers could not afford their American dream of farming. It did not help that the cutover was often portrayed negatively by the media. When Pres. Calvin Coolidge vacationed in Douglas County, reporters referred to the region as a wild and isolated area. The isolation also drew gangsters, which also reflected poorly on the northern counties.

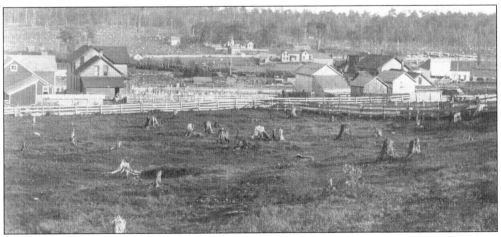

A snapshot of Woodville from the top of Stockman's Hill in 1888 shows the progress some farm families were able to make, despite lack of time and money. Some families not only existed but actually thrived in the cutover. For many immigrants, this was a chance to develop family security and give their children a chance that was not accessible to them in their native countries. (Woodville Community Library.)

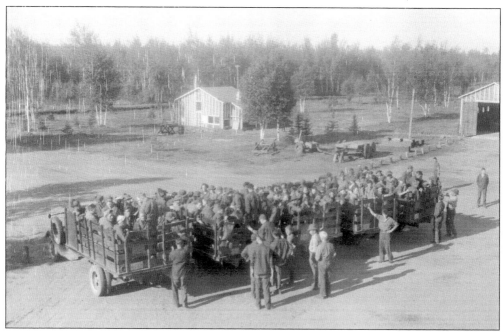

This is a view of men working at the Civilian Conservation Corps Camp Riley Creek near Park Falls in northern Price County. In 1933, President Roosevelt began the CCC, putting men to work planting trees, learning about water conservation, combatting erosion damage, building dams, and clearing slashing in the cutover land. (USDA Forest Service, Chequamegon-Nicolet National Forest.)

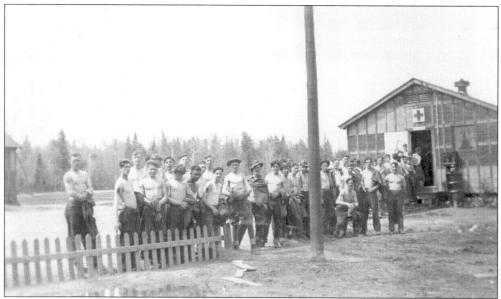

New CCC recruits, called "rooks," are in line for physical exams in 1938. The CCC operated 75 camps in the cutover. Each camp consisted of about 200 to 250 workers. Many men survived the Depression working in these camps, and the country benefited greatly as well. By September 1935, more than 500,000 men spent six months to a year in CCC camps. (USDA Forest Service, Chequamegon-Nicolet National Forest and Claude Van Hefty.)

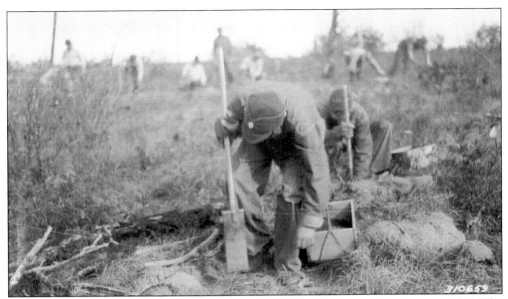

Planting trees was an important chore at the CCC Camp Delta near Iron River in 1935. The work focused on soil conservation and reforestation of the logged lands. The men planted millions of trees. In addition, they built wildlife shelters, stocked rivers with fish, restored historic battlefields, and cleared beaches and campgrounds. (USDA Forest Service, Chequamegon-Nicolet National Forest.)

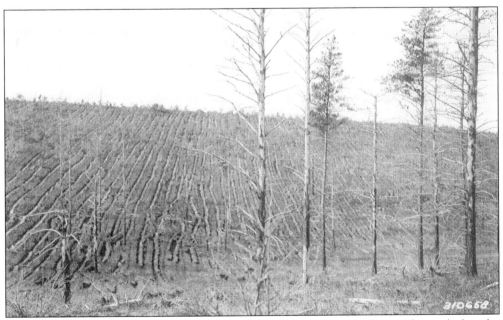

Seedlings were planted by CCC crews in Bayfield County near Iron River. The work that the CCC did in Wisconsin was crucial to the development of tourism that began to flourish after World War II. Today, more than 2.2 million acres of forests exist in Wisconsin. Perhaps someday, these trees will equal the magnitude of the original pines that populated the state for hundreds of years. (USDA Forest Service, Chequamegon-Nicolet National Forest.)

BIBLIOGRAPHY

archive.org/stream/danielshawlumber00reyn/danielshawlumber00reyn_djvu.txt.

Cowley, Mert. *Beyond the Shadow of the Pines.* Chetek, WI: Banksiana Publishing, 2003.

———. *There's Daylight in the Swamps.* Chetek, WI: Banksiana Publishing, 2002.

Gough, Robert. *Farming the Cutover.* Lawrence: University Press of Kansas, 1997.

Hidy, Ralph W., Frank Ernest Hill, and Allan Nevins. *Timber and Men: The Weyerhaeuser Story.* New York: MacMillan, 1963.

Johnson, Kevin. *Early Logging Tools.* Atglen, PA: Schiffer Publishing, 2007.

lacrossehistory.org/business/lumberindustry.

Pfaff, Tim. *Settlement and Survival: Buildings Towns in the Chippewa Valley, 1850–1925.* Eau Claire, WI: Chippewa Valley Museum Press, 1994.

recollectionwisconsin.org/lumber-camp-life.

Ronnander, Chad. "Many Paths to the Pine: Mdewakanton Dakotas, Fur Traders, Ojibwes, and the United States in Wisconsin's Chippewa Valley, 1815–1837." PhD diss., University of Minnesota, 2003. Unpublished.

Rosholt, Malcolm. *The Wisconsin Logging Book: 1839–1939.* Rosholt, WI: Rosholt House, 1980.

Twining, Charles E. *F.K. Weyerhaeuser: A Biography.* St. Paul: Minnesota Historical Society Press, 1997.

About the Chippewa Valley Museum and the Paul Bunyan Logging Camp Museum

The Chippewa Valley Museum is a regional history museum located in Eau Claire, Wisconsin, and is situated right next door to the Paul Bunyan Logging Camp Museum in Carson Park. Open year-round, the museum seeks to connect people to the community and inspire curiosity by collecting, preserving, and sharing our region's historical and cultural resources. More information can be found at www.cvmuseum.com.

The Paul Bunyan Logging Camp Museum has been presenting and preserving logging history since 1933. The camp, a replica of an 1890s logging camp, is annually open to the public from May 1 to September 30. The Paul Bunyan Camp allows visitors to experience life in a logging camp and learn about the history that shaped much of the Midwest. More information can be found at www.paulbunyancamp.org.

DISCOVER THOUSANDS OF LOCAL HISTORY BOOKS FEATURING MILLIONS OF VINTAGE IMAGES

Arcadia Publishing, the leading local history publisher in the United States, is committed to making history accessible and meaningful through publishing books that celebrate and preserve the heritage of America's people and places.

Find more books like this at
www.arcadiapublishing.com

Search for your hometown history, your old stomping grounds, and even your favorite sports team.

Consistent with our mission to preserve history on a local level, this book was printed in South Carolina on American-made paper and manufactured entirely in the United States. Products carrying the accredited Forest Stewardship Council (FSC) label are printed on 100 percent FSC-certified paper.

MADE IN THE USA